# Beginners Drawing Book on Zen Doodle

## + 5 Bonus Templates to Incorporate Your Own ZenDoodle Patterns

Betty D. Caton

Copyright©2016 Betty D. Caton
All Rights Reserved

Copyright © 2016 by Betty D. Caton

All rights reserved. No part of this publication may be reproduced, distributed, or transmitted in any form or by any means, including photocopying, recording, or other electronic or mechanical methods, without the prior written permission of the author, except in the case of brief quotations embodied in critical reviews and certain other noncommercial uses permitted by copyright law.

# Table of Contents

| | |
|---|---|
| **Introduction** | **5** |
| **First Set of Zen-Doodles** | **7** |
| **Second Set of Zen-Doodles** | **13** |
| **Third Set of Zen-Doodles** | **19** |
| **Fourth Set of Zen-Doodles** | **25** |
| **Zen-Doodle Girl** | **31** |
| **Zen-Doodle Leaf** | **37** |
| **Zen-Doodle Dream Catcher** | **42** |
| **Zen-Doodle Flower Hair Girl** | **47** |
| **Zen-Doodle Eyes** | **52** |
| **Conclusion** | **57** |
| **Templates** | **58** |

# Disclaimer

**While all attempts have been made to verify the information provided in this book, the author does assume any responsibility for errors, omissions, or contrary interpretations of the subject matter contained within.** The information provided in this book is for educational and entertainment purposes only. The reader is responsible for his or her own actions and the author does not accept any responsibilities for any liabilities or damages, real or perceived, resulting from the use of this information.

**The trademarks that are used are without any consent, and the publication of the trademark is without permission or backing by the trademark owner. All trademarks and brands within this book are for clarifying purposes only and are the owned by the owners themselves, not affiliated with this document.**

# Introduction

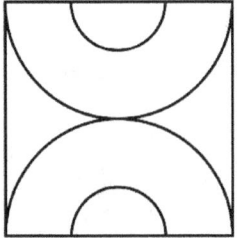 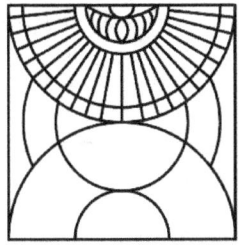 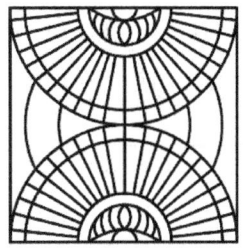

Welcome to a Guide to Creating and Crafting Zen-Doodles. In this instructional and fully detailed guide book you will learn how to draw your own Zen-doodles from the hand crafted patterns and pictures in each segment of the book. There are nine sections in total and it will start off relatively simple and then the difficulty level will increase as you go. We will start with doing four sets of six square Zen-doodles, then move on to five more complicated and difficult Zen-doodles. The Zen-doodle utilizes all forms and variances of the different kinds of shapes in its formations. From squares and rectangles, to circles and triangles. Zen-doodles is an incredibly relaxing and tranquil form of art that allows you to lose yourself in the creation of the actual design before you even consider whether or not you want to color it.

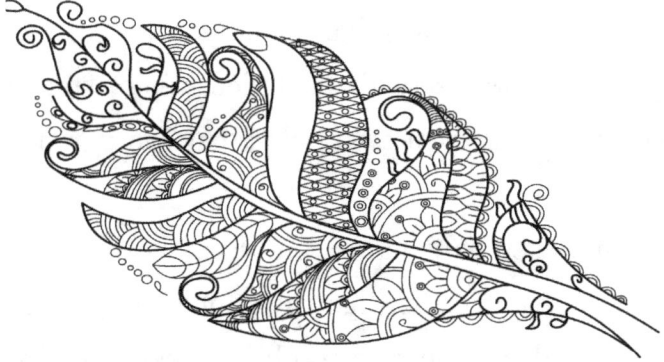

A basic Zen-doodle can take no more than 10-15 minutes to make while the more complicated and elegant ones could be even triple that amount of time. There is a Zen-doodle for every need you could possibly have. If you

just need to wash away the stresses of your job or daily schedule, or if you need to focus on an upcoming project and need something to clear your mind so you can get to it. Even if you've had a rough week and need to unwind and let the weight of a burdened day slip from your shoulders.

There is no end or limit to what you can truly achieve through Zen-doodling. It may at first seem like simple drawings, or basic doodling, but with a proper understanding of how it's done you can reach a higher plain of contemplative thinking. Logic, reason and even will can be enhanced through the practice of Zen-doodles. The task itself forces your mind to evolve and shape itself to each new doodle that you unravel and tangle before your eyes. The process itself is never ending and can be applied and reapplied to as many different designs that you can come up with or find. The beauty of this guide is that while it comes with a varied and lengthy list of Zen-doodles; by the time you've completed each one you should in fact be able to go off and create your own from what you've learned in this book. Each illustration will be provided with a detailed step by step examination of what's required to create and craft each individual Zen-doodle.

The materials are quite self-explanatory but do make sure you have enough paper handy as well as a straight edge ruler for getting those crisps lines. You also want to consider some nice soothing music and an herbal tea to really set the tone for your afternoon endeavors. One final thing before you embark on a Zen journey of profound doodling. Take your time with this book and work your way through each separate doodle with care and

patience. This is an activity that needs to enjoy with the proper sense of calm and tranquility. Don't rush through it and forgo the enjoyment of truly immersing yourself in the peaceful vibes of the Zen-doodles. Aside from that, dive in and enjoy it. Make the most out of every single illustration and really let yourself sink into the images. There's a whole big wide world of Zen-doodles out there to experience so quit reading this introduction and really get started now!

# First Set of Zen-Doodles

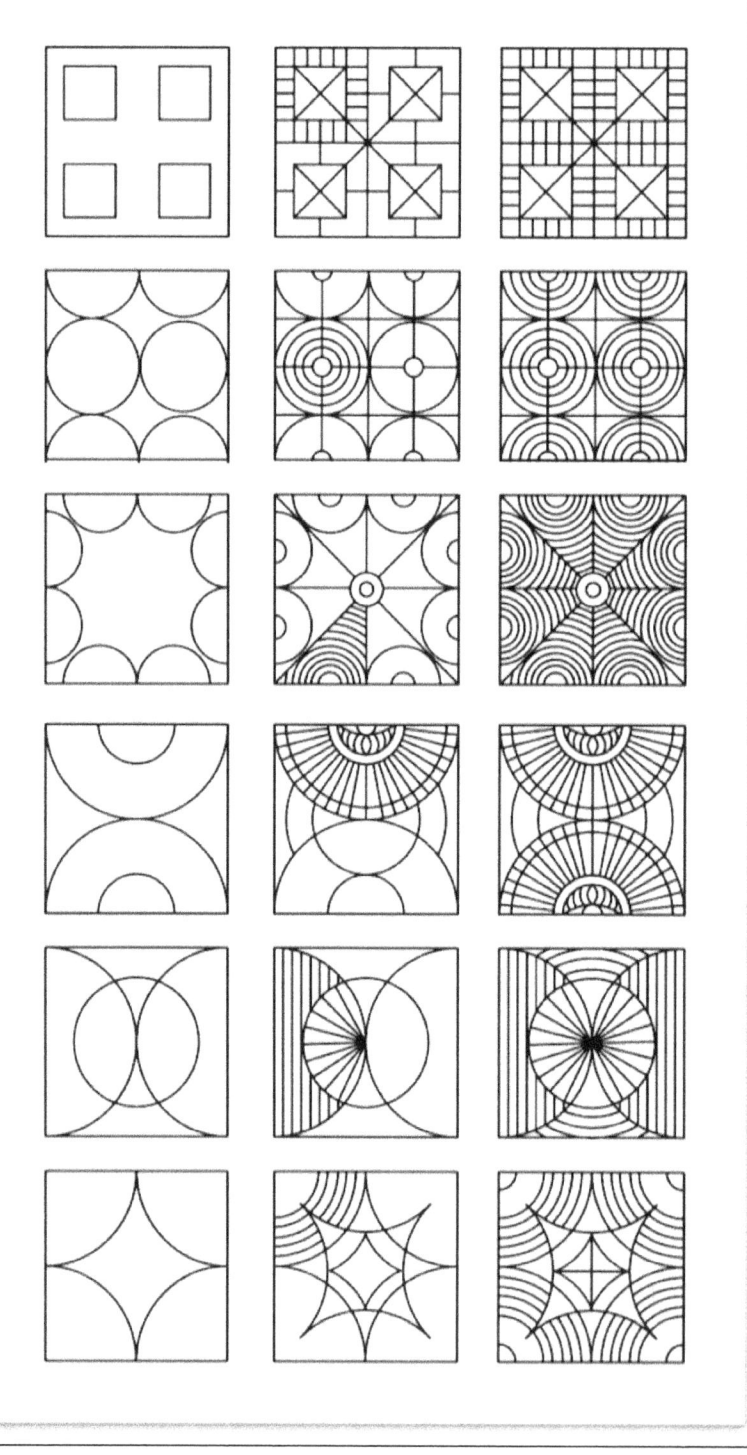

The first set of Zen-doodles is depicted to the right. There are six in total that you will be drawing. The size of the photo isn't a hard-fast rule pertaining to the size of them once you draw them yourself. In fact I would encourage you to draw them in a much larger size anyways. Being that there are four sections of these six sets of Zen-doodles let's just dive right in to the first one at the top. For this you will need to use a pencil with an eraser, and a ruler; you could even consider a protractor if you have one for the circle shapes.

# Number One

The first one at the top is relatively simple to do. You start with a square as they all are in this segment. Then you will proceed to draw four more squares within the main square. Then once that's accomplished. Draw straight lines to make a cross in the middle of the main square and an X in the smaller squares. Follow the images diagram and draw smaller straight lines within each individual square section. Follow the image to the right in order to understand the exact design. The final step for the first Zen-doodle is to fill in the majority of the sections with smaller straight lines. The end result should be identical to the one on the top and far right. Get as straight lines as you can use a ruler.

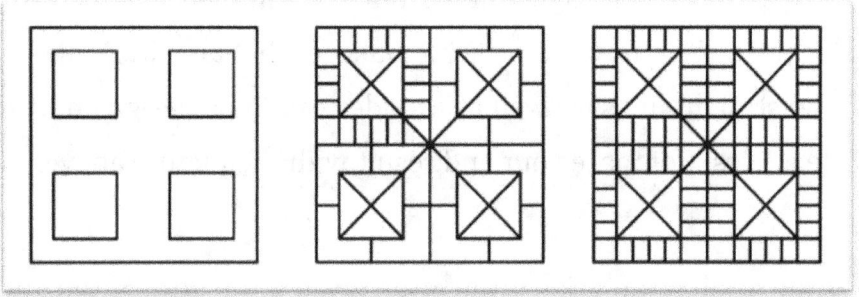

# Number Two

The second one is slightly different from the first, this time focusing more on circles than anything else. You start with the same main square and then draw two full circles and four half circles. The next step is to draw straight lines between each circle across the whole main square and a bullseye or target design in one of the circles. After that, your next step is to fill the half circles and the last remaining full circle with the same design as the first one. The end result should be identical to the above image.

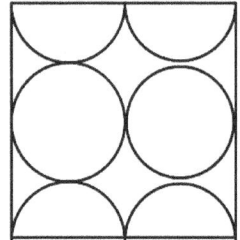 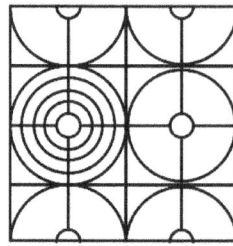 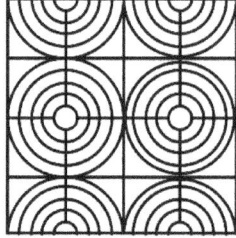

# Number Three

The third one is somewhat similar to the second. Starting with six half circles around the inner edges of the square. Then draw two smaller circles in the dead center of the square, and small half circles in each of the larger half circles. As well as straight lines from the middle circle to in-between each half circle. The next step is to make each half circle like a target although no straight lines, as well as a spider web type design emitting from the middle circles. Compare your end result with the picture above.

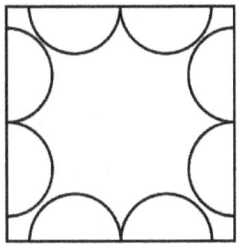 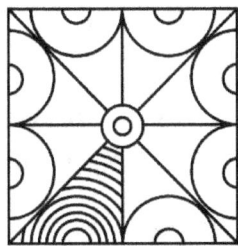 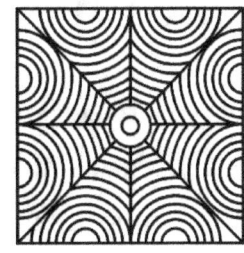

## Number Four

The fourth one is again a little different although still using the same half circle style as the third. This time you draw four half circles in total. Two on either side across from each other. The larger half circles should touch each other while the smaller ones should not. The next step is to create a roulette look in the upper larger half circle, and two curved lines in between the half circles. You can draw a full circle in the middle in order to get the lines accurate and then erase the portions that intrude on the half circles. In the smaller half circles you'll want to follow the design closely to create an almost half eye on the bottom with curved lines that connect it with the half circle above. The last step is to make the bottom half circle the same as the top one. Fill in the lines as you did for step two, and then you're finished. Check your work against the image.

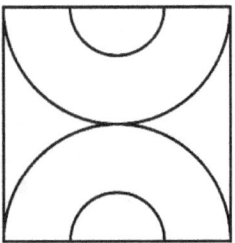 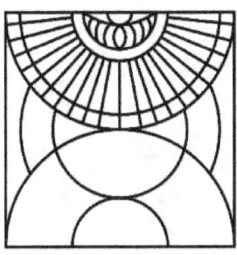 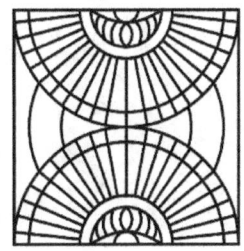

# Number Five

This one is relatively simple and requires you to employ some of the techniques you learned from the third and fourth one in this section. Do two half circles on opposite ends of the inner main square as well as a smaller but medium sized full circle in the middle. Fill the two half circles with straight lines from top to bottom while the full circle should have lines going from the middle outward but only in the sections that cross over with the half circle. In the space unoccupied by any circles overlapping draw curved lines from half circle to half circle. Relatively simple but still fun and relaxing to draw.

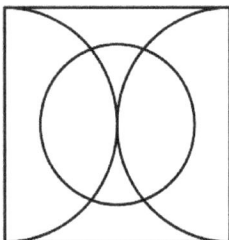 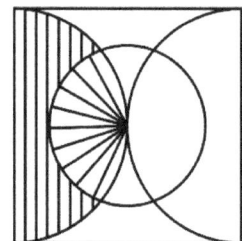 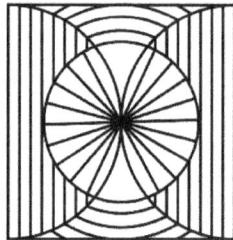

# Number Six

This one is more intimidating upon first look. It's really not so bad if you employ the skill of utilizing half circles to create other shapes. That's how you get the overlapping diamond shapes in the middle. Once you have those locked down then it's all about drawing multiple half circles and filling out the middle. Follow the diagram up top and you shouldn't have too much trouble. Remember to use a ruler for the straight lines that there are

 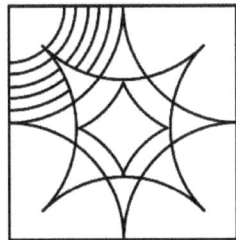 

# Second Set of Zen-Doodles

The second set is much like the first. Another group of six that will require a pencil, ruler and a protractor should you has one. Remember, this is all about relaxation and tranquility. That is the intent of the game so breathe deep and remember that these instructions are merely guides so that you can start creating these all on your own without needing help at all. Enjoy and move on ahead to the next set!

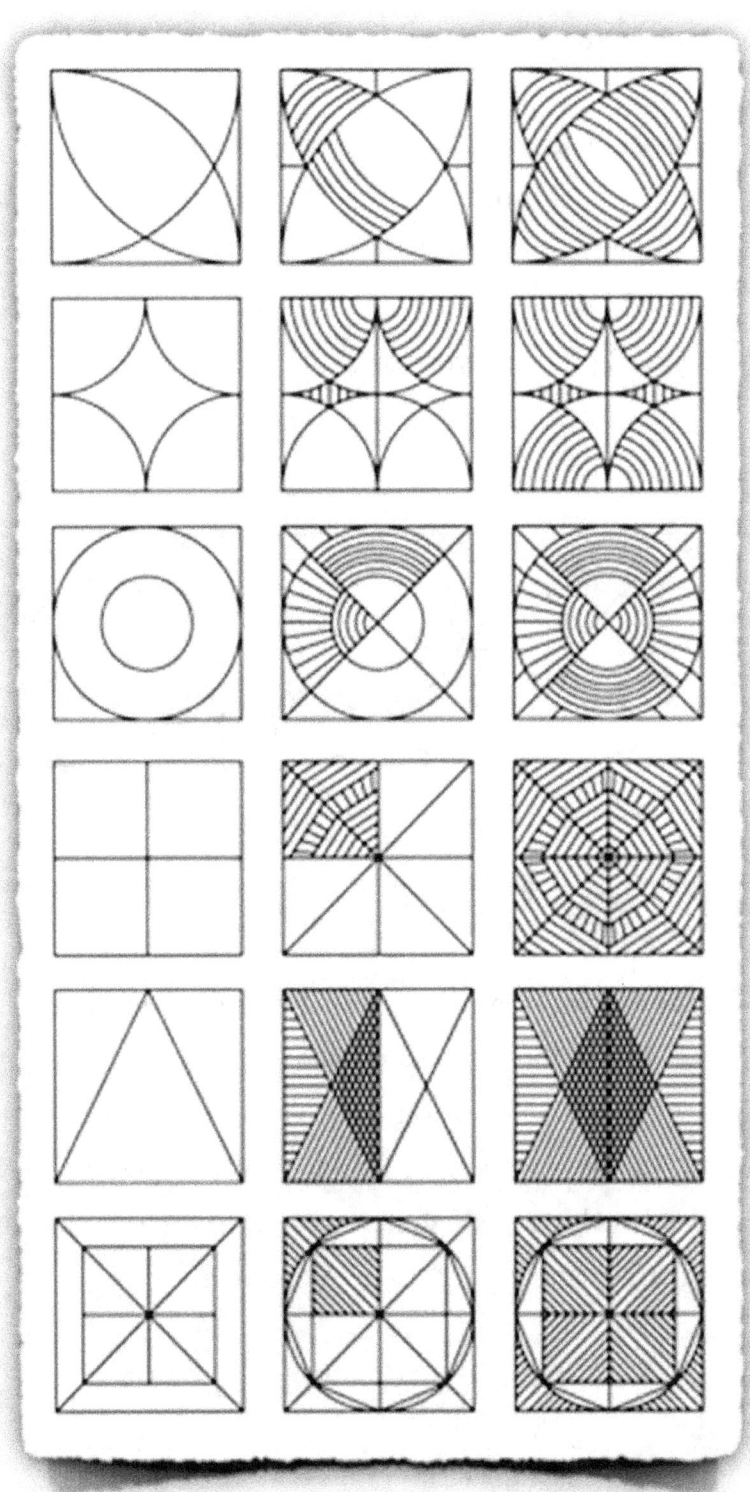

15

# Number One

This first one focuses more on curved lines and less on any actual shapes. The important thing for this one is to focus on the intersecting lines and use those as guides. There's at least four to start with. Follow the diagrams above and then add in the four smaller lines in the middles of the intersecting shapes. By the end your drawing should look like the one at the top above.

  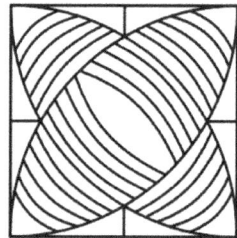

# Number Two

This one will remind you of a few of the ones from the first set. It is very comparable to several of those ones and shouldn't take you too much effort to create. The main thing to focus on for this one is the lines in the middle, the smaller ones that connect the half circle shapes together. As well as the record style look of the lower half circles. Also keep in mind that there's a lot of breaks in the pattern and empty space in this one.

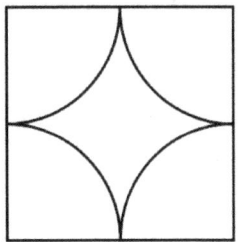 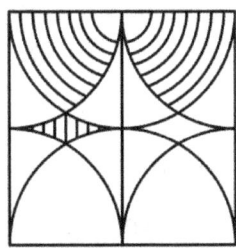 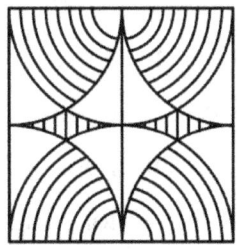

## Number Three

This one again is like others you've dealt with that focus mainly on circles and variations of the round shape. As you'll notice this one seems to resemble that of half a record and half a dartboard. That is something to keep in mind moving forward with it. Your biggest ally with this one will be the straight lines that cut the circles into quarters. Draw those nice and straight and set about creating the dartboard and record looks in each appropriate quarter. You'll find that it winds up being easier than it looks and thusly a very relaxing doodle to accomplish.

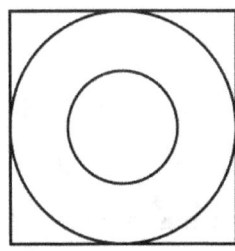 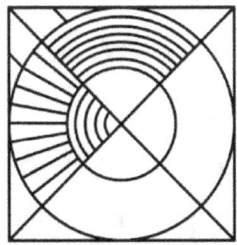 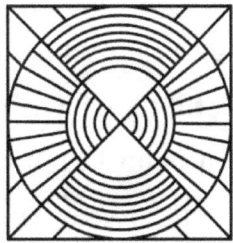

## Number Four

This is where the doodles start to get more complicated and include far more intricacies then the last ones. This one in particular makes heavy use of the ruler and small lines. To start you need to draw two lines in the main

square so you have four smaller squares. Then you do two more lines in the form of an X in the middle so you have 8 segments in total. Then once you've done that you'll want to take a close look at the second image and see the way in which the lines are situated. There is a vast amount of small lines all linking the sections together but then there's a break in the pattern in the middle with lines going the other way and are even smaller. Once you've gotten that, lather rinse and repeat for the rest of the segments of the square.

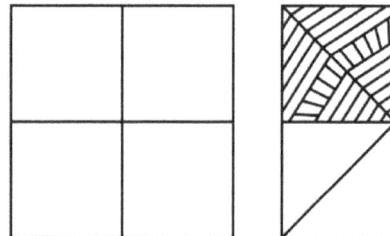

# Number Five

This one looks far more daunting than it actually is in reality. You draw two large triangles that take up the whole square. Then you draw straight lines from the bottom at the same angle of the main line that you'll draw in the middle from point to point of the triangles. Keep in mind that you want to follow along the line of the triangles and have the lines meet in the middle line along either side. Then in the spaces not occupied by triangles you'll want to draw lines across. Super simple and serene for one with such a fierce look too it. Remember to take your time with each drawing and don't rush yourself.

 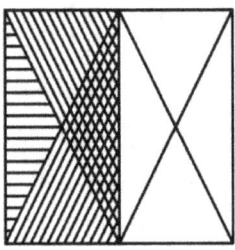 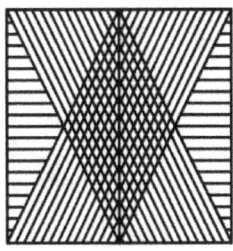

## Number Six

This one is definitely the most complicated we've come across thus far and will most likely require a certain level of patience while making it. I recommend you take a good look at the first image and study it for a moment. Start with the lines from corner to corner, and then I recommend doing the four squares in the middle. This is when you need to employ some of the technical skills from the previous doodles and pay attention to the curved lines. Draw them carefully and don't be afraid to erase lines and restart if you have to. Once you get the lines figured out and move on to the next step, don't be daunted or tormented by the amount of line work required. Just take a breath and make those symmetrical lines. It may take a moment but the finished product is worth it. That completes the second set of Zen-Doodles. On to the next section!

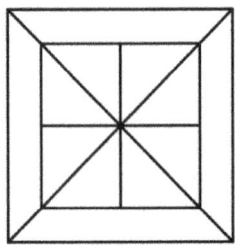  

# Third Set of Zen-Doodles

Now we get to the hard stuff. By now you're an ace at utilizing circles, curved lines and squares. Now you'll need to use all that you know what eaten learn some more to get these ones down. There are a lot more intricate shapes in these next six as well as some very specific line work. Do your best to follow the designs as closely as possible and hopefully the instructions will ring through clearly and you'll be a professional in no time!

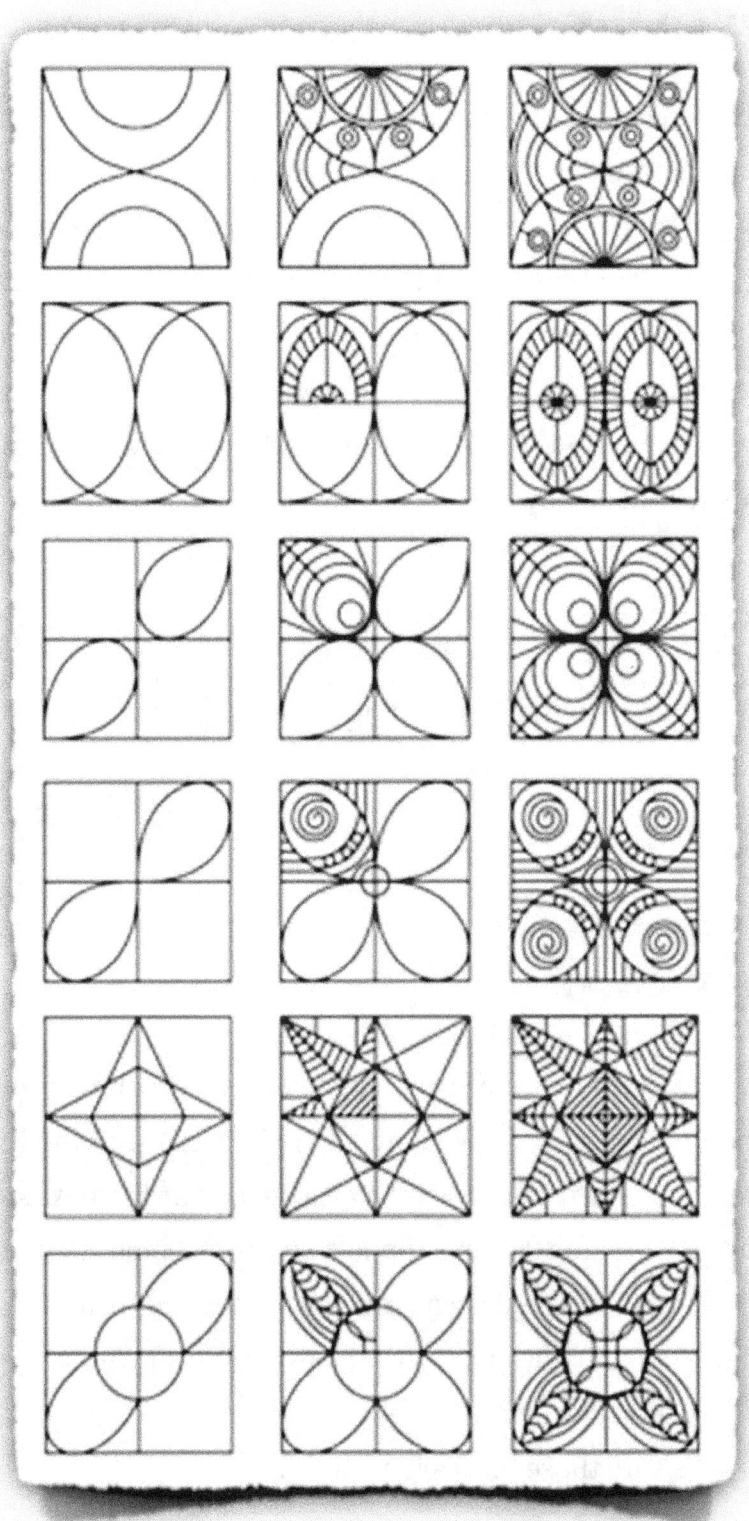

# Number One

With this first one you can already see that it's a little more complex than the last sets. Start with the two half circles on the top and bottom and then get those S curves from bottom corner to top corner. The second step is going to require some finesse and fancy line work so pay close attention to the curved lines between the two dome shapes as well as the lines in between the half circle and the middle lines. Once you've got a good grasp on the upper design, do the same on the bottom and you've have the first doodle of this set nailed down!

 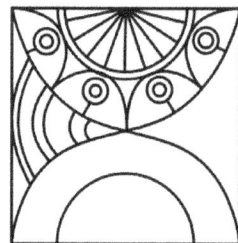 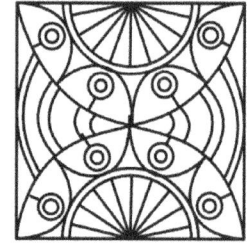

# Number Two

This one is another familiar piece and slightly less difficult than the previous one. Use what you already know about the half circles and the line work to get the first image drawn up. Now take a close look at the next step and see what's required of you for the first top left quarter. Seems complex but once you get the small half circle drawn, you can do the half oval shape above it then begin filling in the lines. Look at the next step and you can see what it's expected to look like. Pay attention to the symmetry of the two sideways eye shapes and make sure those lines are straight.

 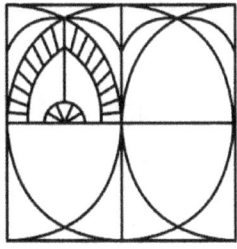 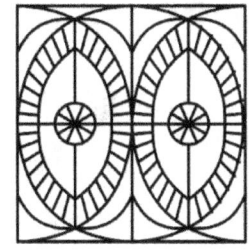

## Number Three

This one is a bit different than we've dealt with so far. it puts a definite focus on more oval shapes and curved line work than we've dealt with yet. Get your four corner squares drawn up with the ovals pointing to the middle. This one has a definite focus on curved lines with emphasis on the middle lines that intersect through the middle portion of the main square. Pay attention to those and be careful that your lines don't touch where they aren't supposed to. Get those small circles drawn up and then make sure your straight lines are in place.

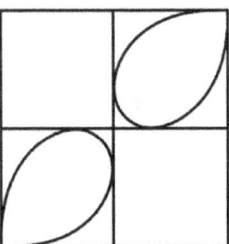 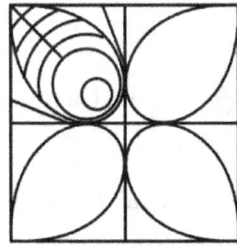 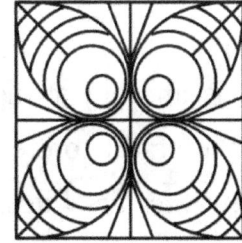

# Number Four

This one is a lot like the one we just did, almost identical save for the patterns. Get your four corner squares drawn up with the ovals pointing to the middle. Get a small circle in the dead center and then work on the design in the middle of the oval as seen in the second step. Take your time with the swirl design and focus on keeping the curved lines even. Once you get that down then finishing it should be too tricky. Remember to take your time and breathe properly while doing these exercises; otherwise it can offset the tranquil atmosphere.

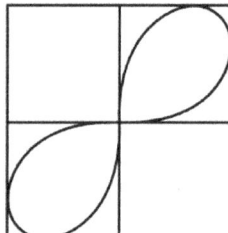 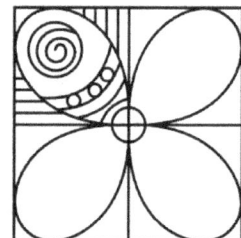 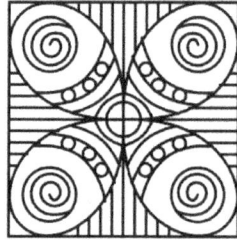

# Number Five

This one is another straight line masterpiece. Requiring a lot of straight lines that intersect to create different shapes. Break out that ruler and get started on the first design in the image, making sure to keep it as symmetrical as possible while laying down each diamond shape. Moving on to the next step you can see that it starts to get more complicated with even more overlap. Focus on the triangle shapes that you can lay down before starting on the more intricate stuff in the corner. Once you've gotten all the long straight lines figured out you can start getting the shorter ones put together. It shouldn't be too hard to master as they only serve to connect lines together and there isn't much more overlap or intersecting. Once

you've gotten that done, do the same to the other three segments and you're done!

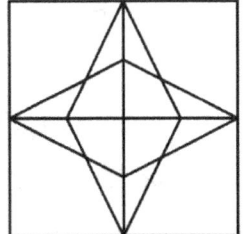 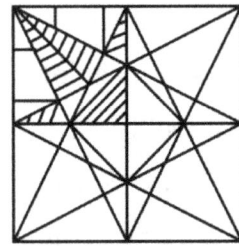 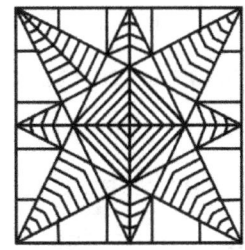

## Number Six

This is another one like the third and fourth that you did earlier. So I encourage you to utilize the same techniques you discovered from those ones and use them here. It isn't a vast deal different than the other ones. The main difference is the circle in the middle and the more intricate design within each oval and the middle circle. So watch your curved lines and use circles and other curves as best as you can while keeping an eye on your symmetry. A helpful tool would be to have that protractor handy for this one especially and to make sure that you're paying attention to the middle area. Try your hand at this one and you've just completed the final doodle in this set! On to the final set of these style of doodles!

 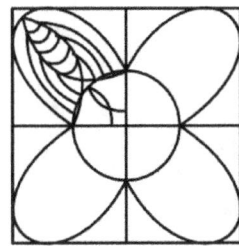 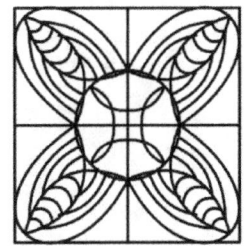

# Fourth Set of Zen-Doodles

This is the final six set of Zen-doodles that you will be tasked with completing. Then the original stuff follows and you put the skills you've learned from these to the real test. Once done with these though I encourage you to try them again when you feel like you need the calm tranquil vibes of a Zen-doodle creation. Also you can try your hand at making your own and coming up with completely unique and original designs on your own. Don't stop at just what's in the book. Dream up whatever you want!

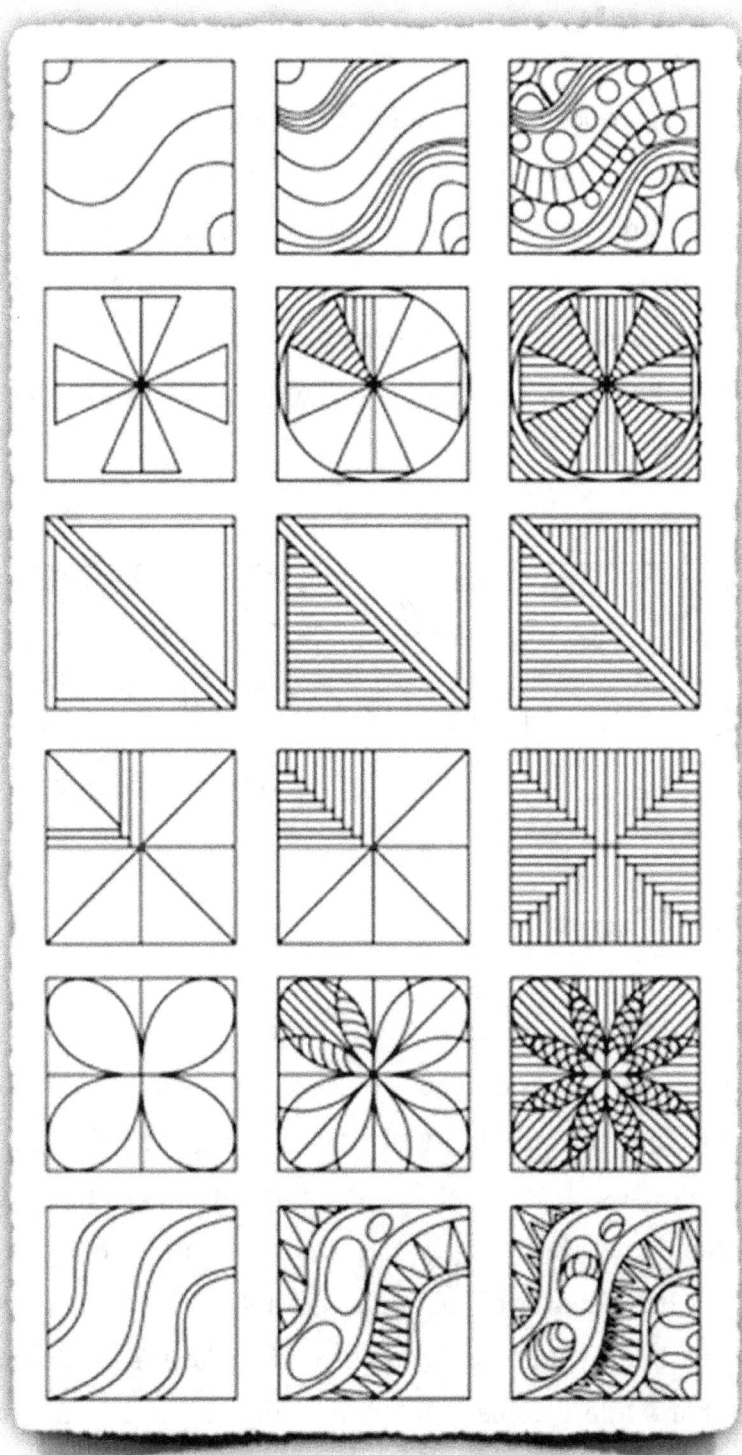

# Number One

This one is a bit of a doozy at first sight but when you look closer you realize that it's just a lot of repetition with connecting lines and some circles. The part that will require the most focus is going to be the half ovals on the top and bottom of the wavy lines. Pay close attention to those while also making sure that you get as symmetrical as possible with the circles. Otherwise this one isn't a huge challenge. Just keep your eyes open and your hands steady! Remember to breathe.

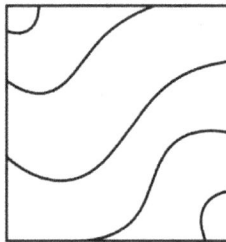 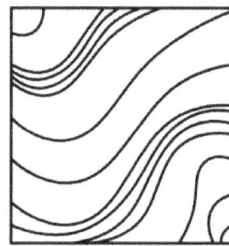 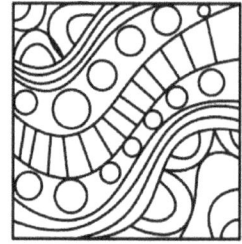

# Number Two

This is another different one that we haven't come across. It focuses on a healthy mix of straight lines and curved lines. Requiring four triangles to be drawn pointing into the middle with lines cutting them in half, and then encircle the triangles. After that its straight lines between the triangles connecting them and then lengthwise lines in the actual triangles. Pay attention to the dead center of this one and notice that the outer edges are all curved lines. Keep your lines straight and make it symmetrical. This is another one that while it looks hard is actually very relaxing once you get rolling.

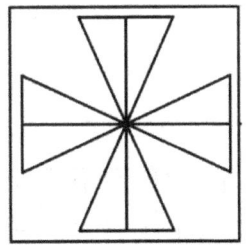 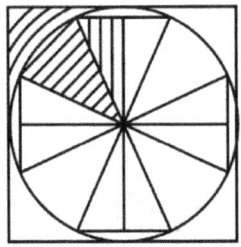 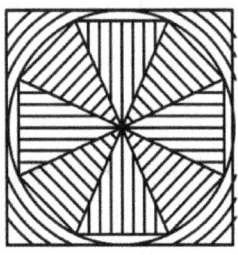

## Number Three

This one is a very easy one, just to break up the tricky stuff. It's all straight line work and relies on the three starting lines to be drawn straight, and then you fill in the rest with long lengthwise lines. No overlapping or intersecting to be found here. Just old fashioned straight edges with a focus on even spaces.

## Number Four

This one is a lot like the last one you just did except it has a major difference off the bat. It wants you to use the diagonal lines as guides for your lengthwise lines that you add into each corner. You will erase those as you progress through each corner. Keep that in mind as you proceed and don't do hard edges on your diagonal lines. Also pay attention to the flow of the steps as you go through each corner and make sure the symmetry is in

check. You shouldn't have any major dilemmas with this one as long as you watch your line work and keep your endgame in mind.

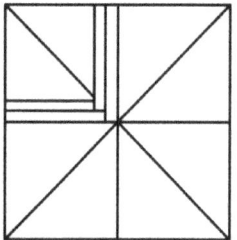 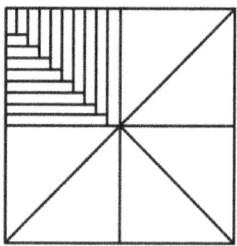 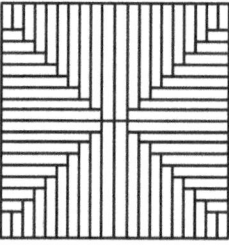

## Number Five

For this one, look back at the past oval ones we've done and draw inspiration from those. You shouldn't find a lot of difficulty in this one but I will help with the problem areas. The middle is a culmination of the leftover space from the oval tips that don't get any overlap. The sections on the sides of each oval are a culmination of overlap from doing the eight ovals on top of each other. Pay attention to the straight lines in each oval and watch out for the overlap. It looks very complicated at first but take it each oval at a time and you shouldn't have too much pause with it.

# Number Six

The final one in the set and the most like the first one you did in this fourth set. Follow the same pattern and watch out for those triangles in between the wavy lines. Give those oval shapes good overlap and keep any edges straight while doing your best to make use of your curved lines in the lack of symmetry. Good job on tangling with this set of Zen-doodles! Now let's get to the more complicated drawings!

# Zen-Doodle Girl

This is the first doodle that isn't part of any set; it's an original design on its own. The key to this first one is following the line work as best as possible and taking your time with it so as to not require too much erasing or starting over.

Step One: Do as you see in the first image on the right, just some basic line work to set up the outline.

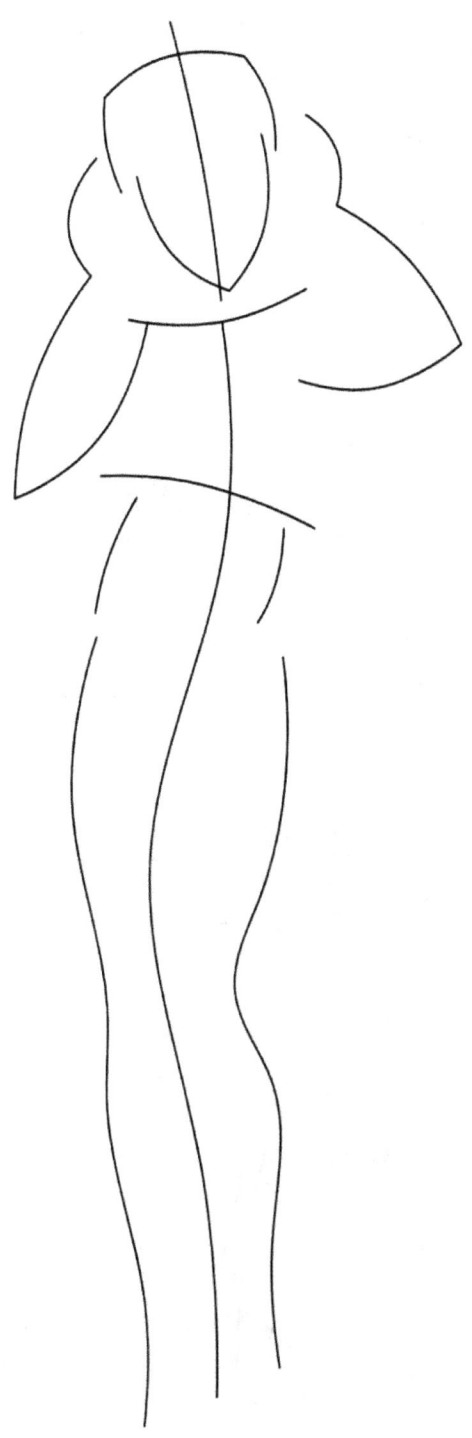

Step Two: Once you've got the basic lifework done its time to start on the actual features such as the hat, dress, arms and legs. Give those a go now and watch the line work.

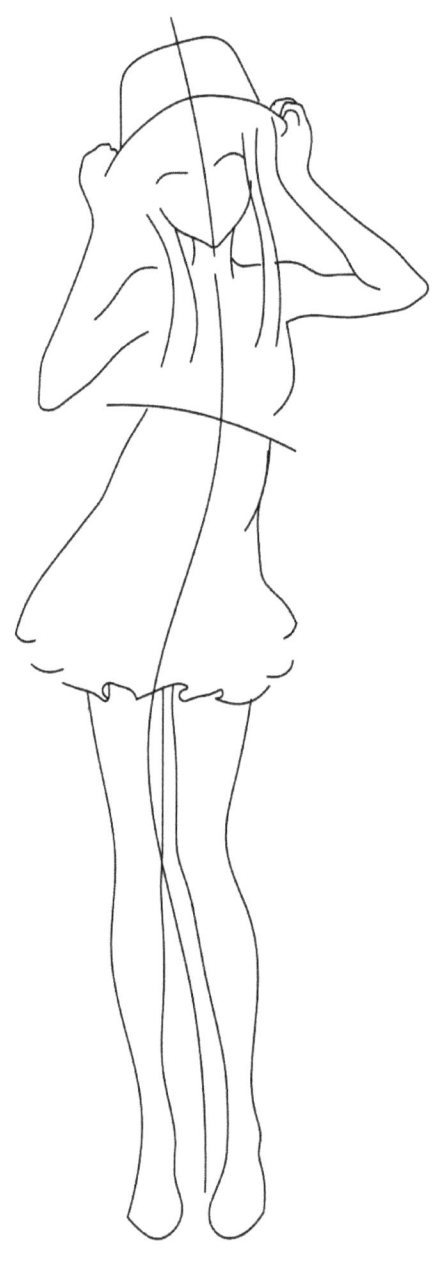

Step Three: Now we get into the more extravagant detail such as the face and the design of the dress. The line work itself into too hard to follow so make sure you check your work with the image to the right.

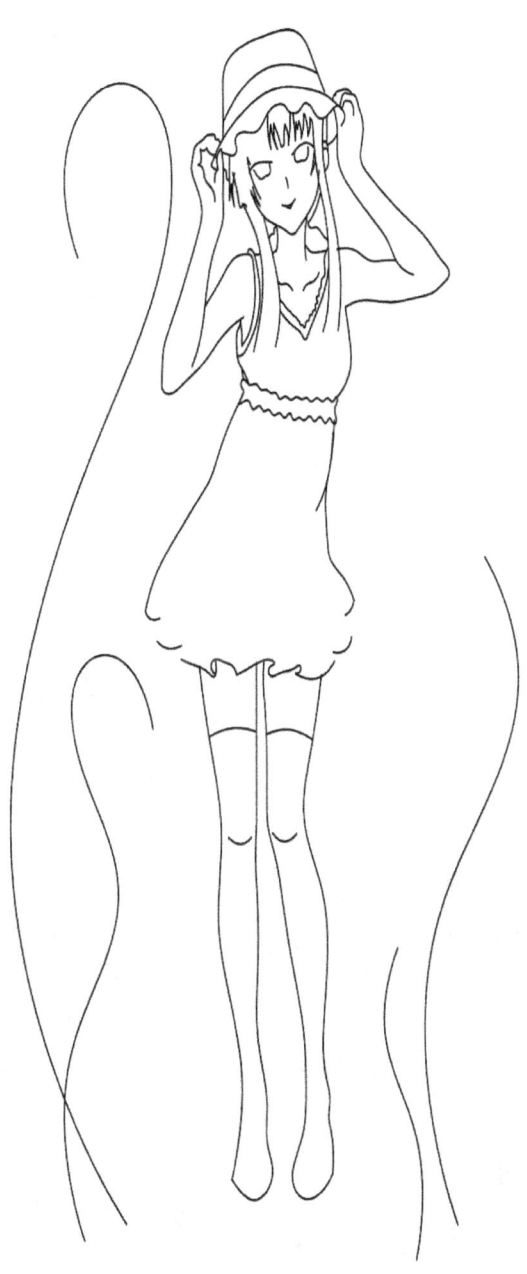

Step Four: The final step is also the most extravagant and the most fun. Do the final details in the hair, eyes, and the legs. Now it's time to add the Zendoodle flowers to the picture. As you can see they aren't too complicated, very mandala like with very flowery designs. Use all the skills you learned from the first four sets of doodles to knock these out of the park!

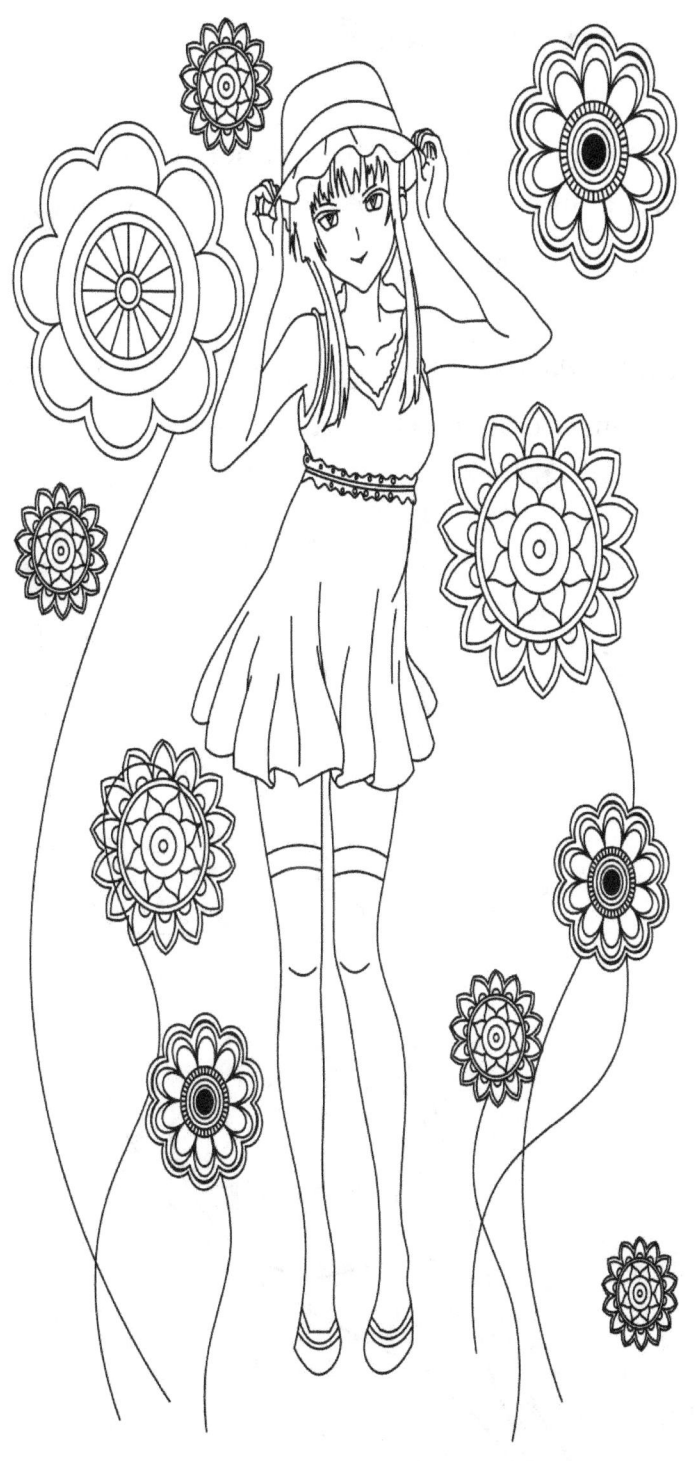

# Zen-Doodle Leaf

This next one is more intricate then the last but also starts off fairly easy to do. A lot of focus on line work and design so pay attention to the design and make sure you take your time.

Step One: Follow the design on the right to get the starting lines correct. Do your best to get them as close to what you see here.

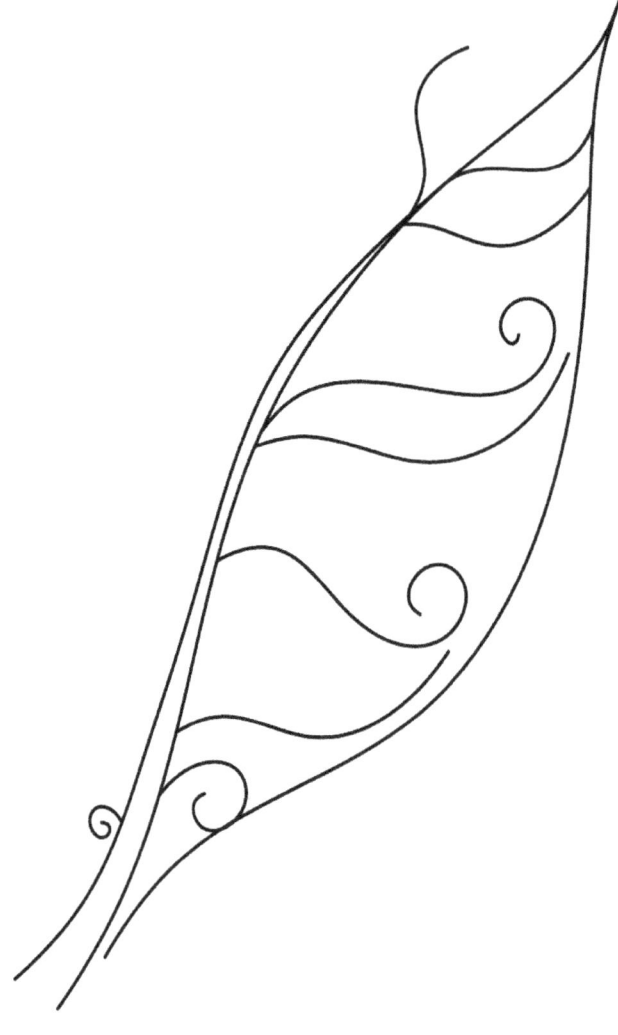

Step Two: Add in the next set of lining to the current image. You shouldn't have to alter anything or make any drastic changes yet. Just keep it to what you see on the right and again, take your time. Make sure you're breathing right.

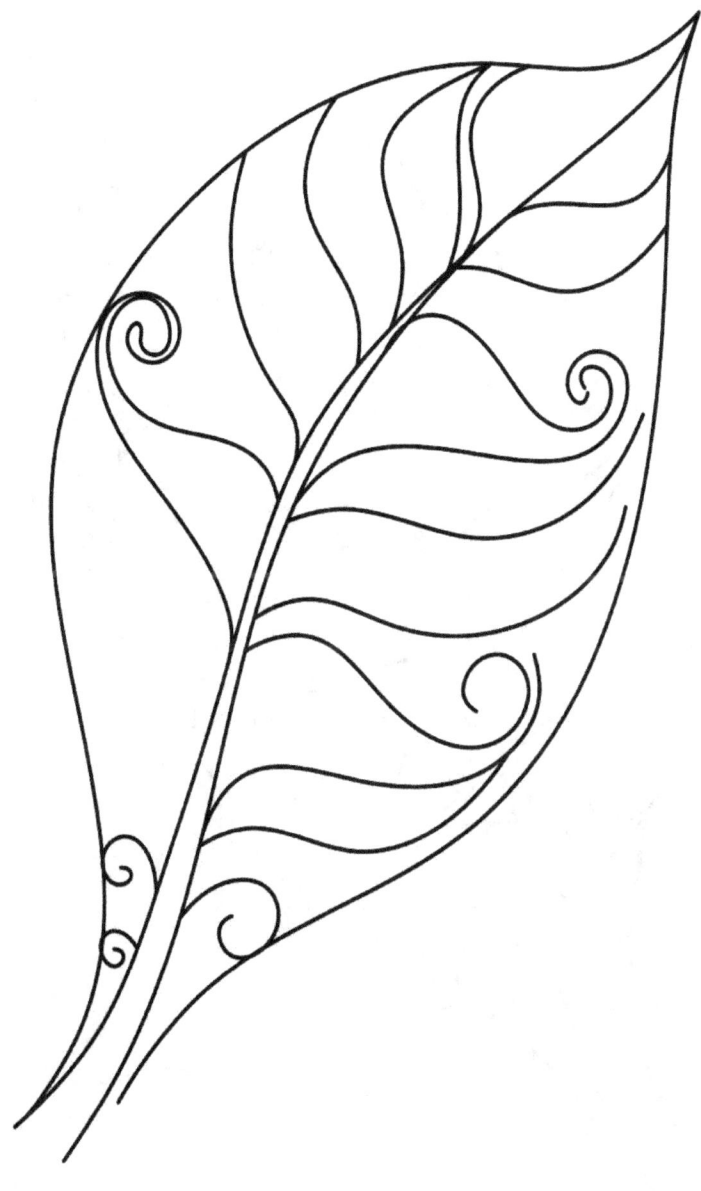

Step Three: Now is when the intricacies start to take shape and really blossom. You will need to partially erase some of the lines you've already made as well as add on to preexisting lines. Follow the image and compare it to the previous one in order to really get a good understanding of the changes.

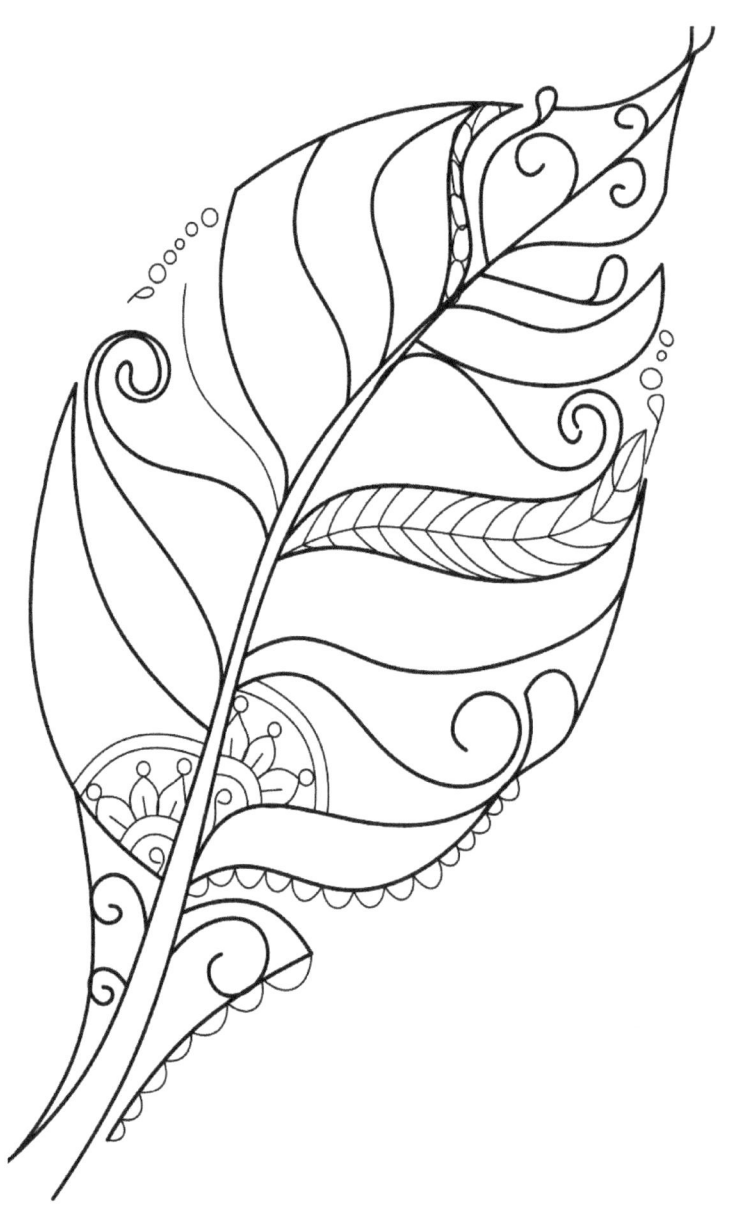

Step Four: The most detailed of the steps and the final step. This one will really take you some time, but that's the fun part! So again use the last image as a reference point and elaborate on the designs and take your time.

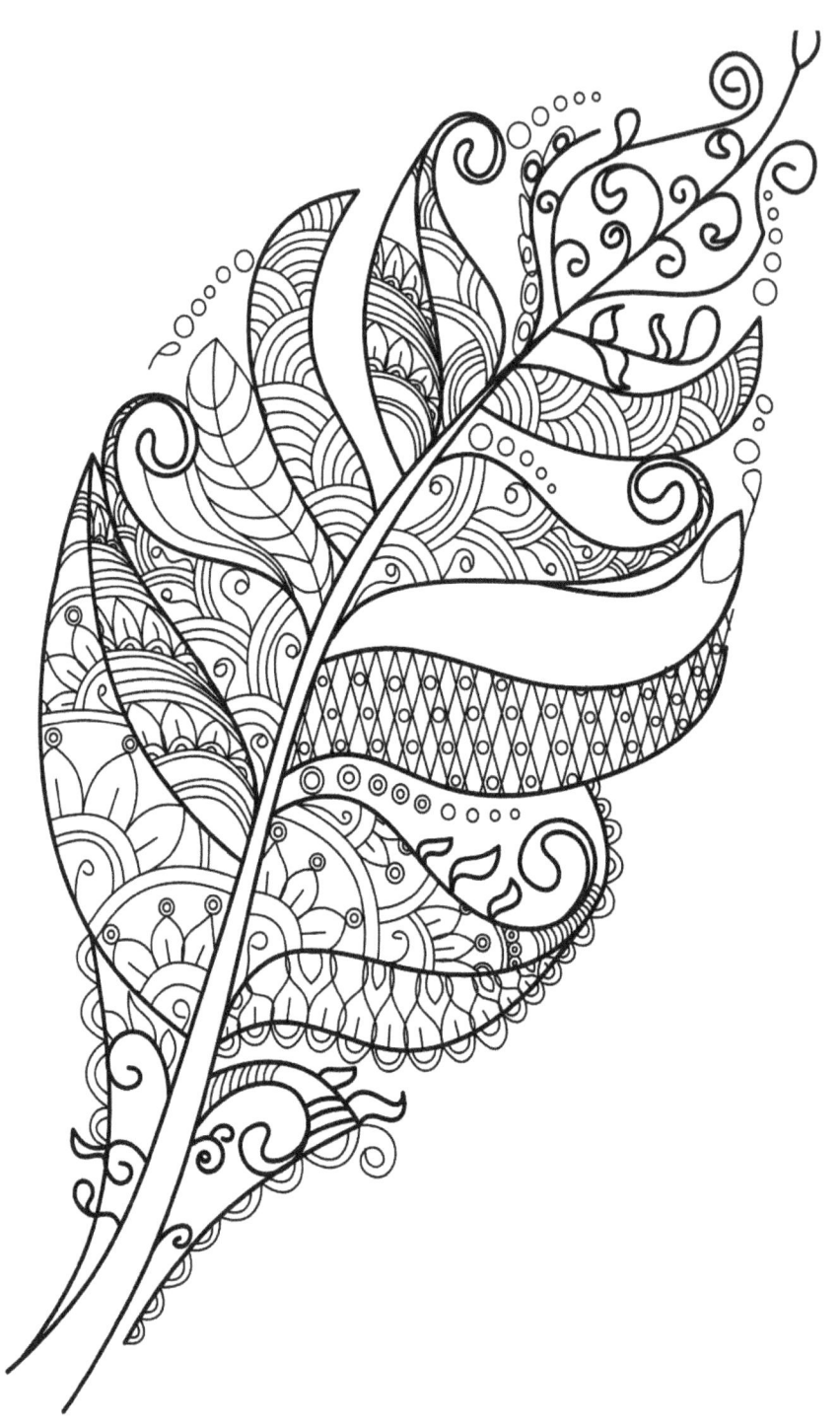

# Zen-Doodle Dream Catcher

This next one starts out a little further along than the last two. As you can tell right away it's the beginnings of a dream catcher. This one has a bit of a stronger focus on the actual item itself so follow along and doodle your very own dream catcher!

Step One: The most important part is the beginning circles; they take the shape of the dream catcher itself so place priority on this. You'll be doing a lot of additions so be careful with how hard your lines are.

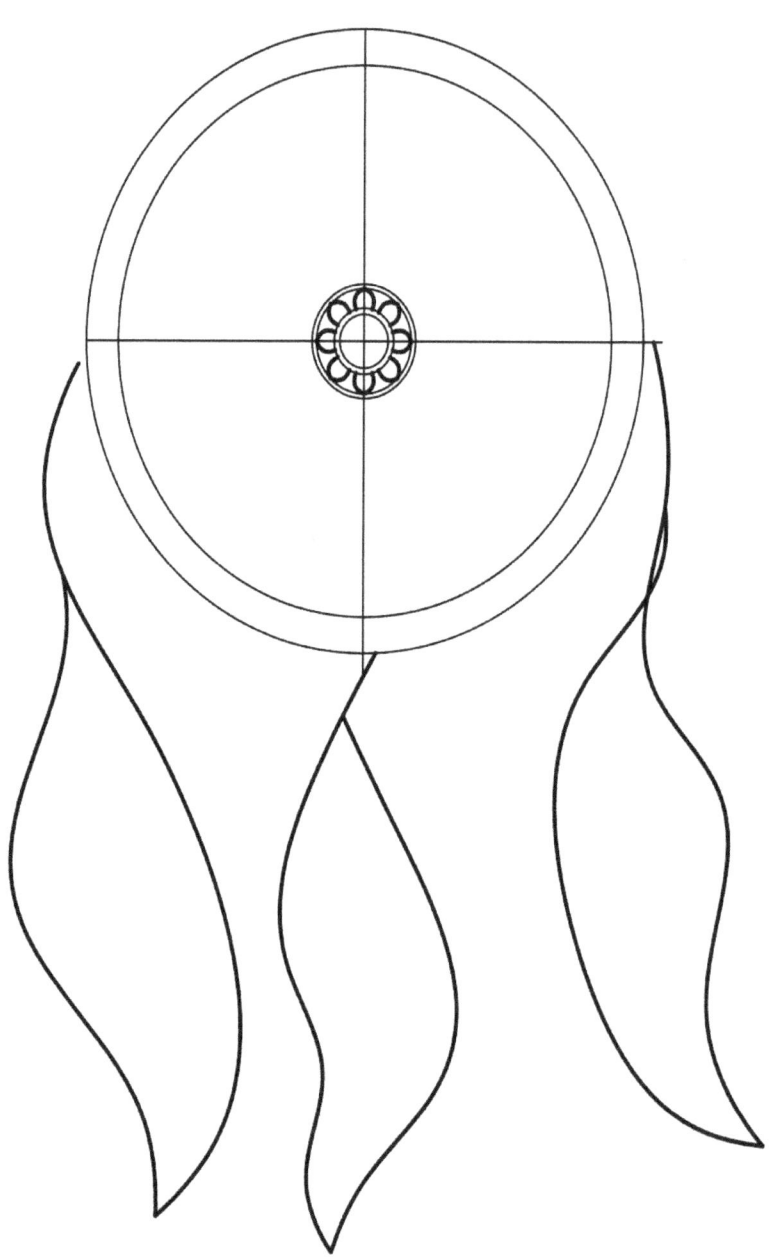

Step Two: Things start getting complicated right away as the design takes shape. There's the beginning of petal shapes in the middle as well as a triangle pattern around the rim. Pay attention to the lining there and watch for symmetry in the dream catcher itself.

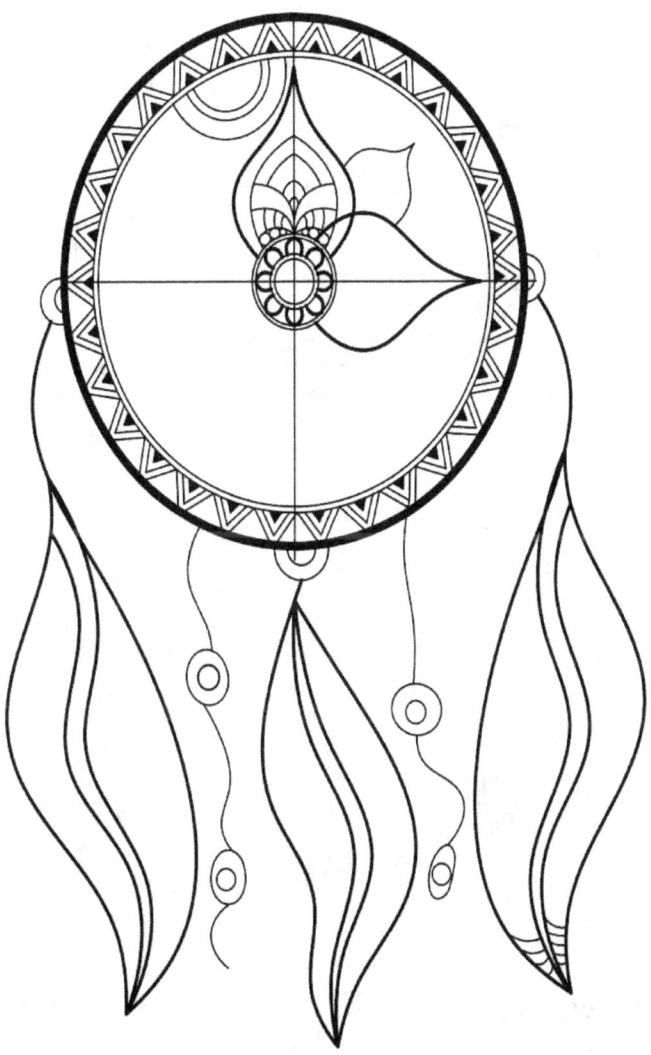

Step Three: As you can see the pattern in the actual dream catcher is really taking shape. You can fill that out as well as get the design on the tassels

perfected. This step sets you up for the last one so make sure you exercise patience when perfecting this line work.

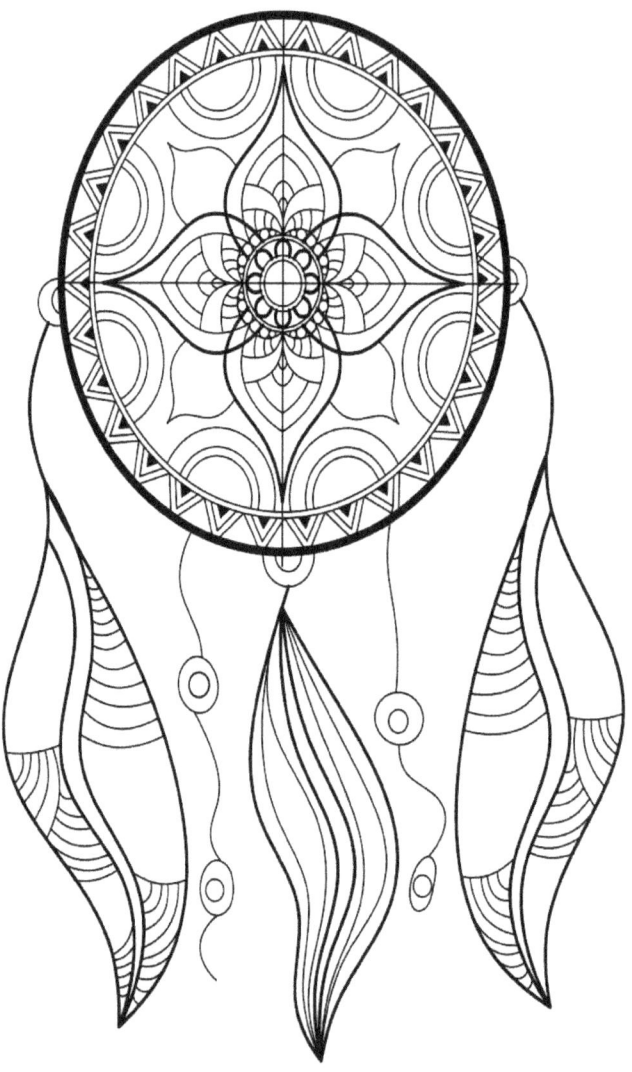

Step Four: This step adds the final flair to the dream catcher, giving it a detailed and beautiful finished look. It's very entrancing and draws you in. It's important to keep in mind that you can spice these up as you like. On new draw through or even on your first time once you're finished.

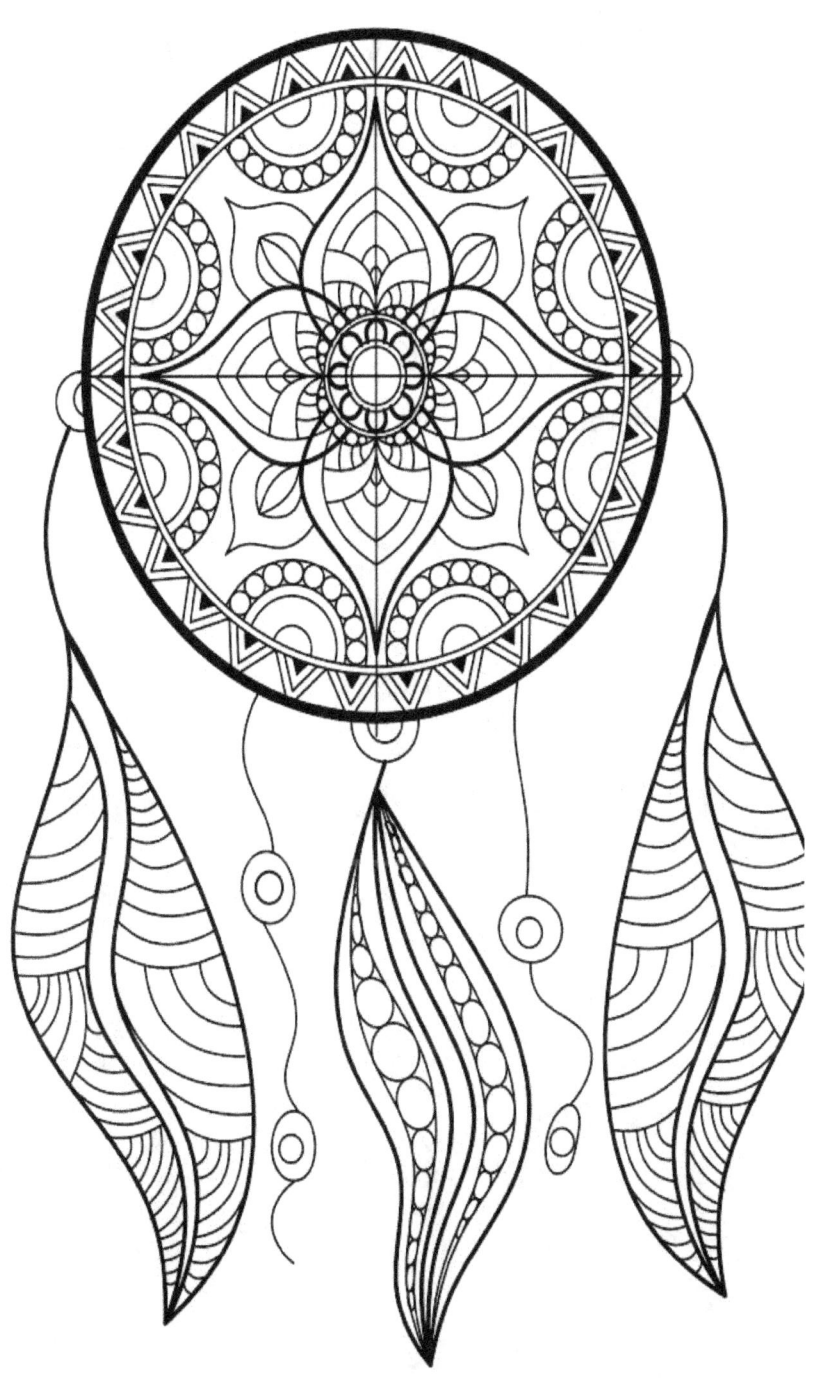

# Zen-Doodle Flower Hair Girl

This next one is similar to the first one you did, yet it starts a little further along but goes farther.

Step One: You start off by drawing a woman face and hair. As you can see the lines for the hair are bold, so make sure you follow suit in your doodle. Place importance on the eyes as well.

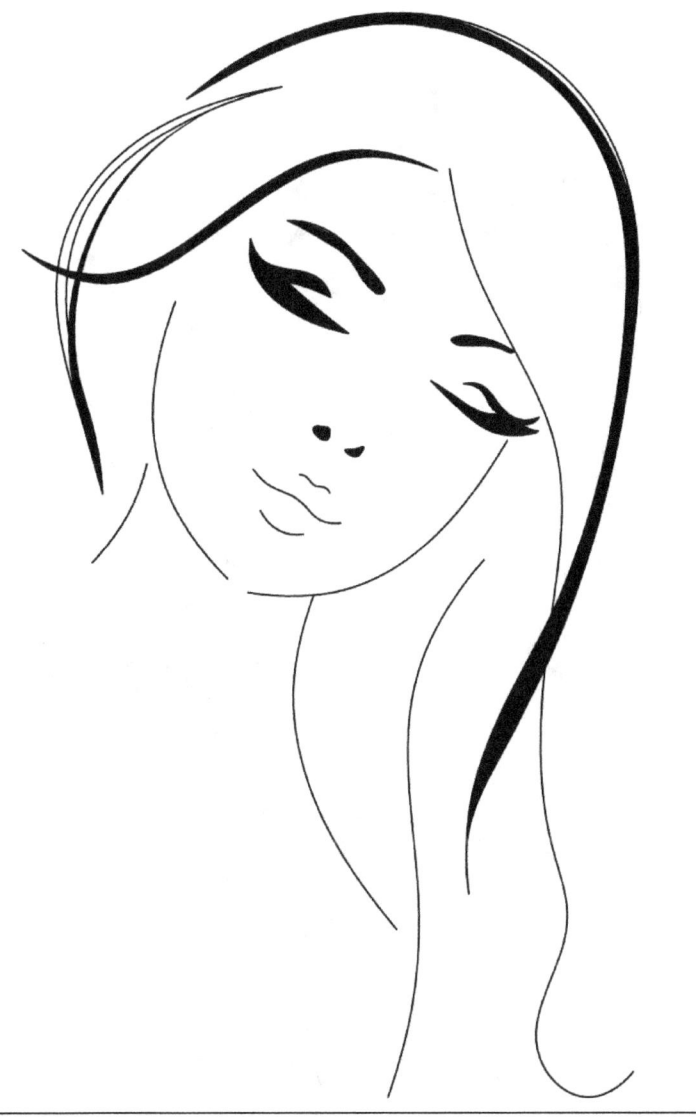

Step Two: The going gets tough quickly on this one, but you've learned so much that it's time to exercise all that vast knowledge. Get started on the flowers that highlight her hair as well as the leaves that accompany them. Watch your curved lines and also pay attention to the bold lines.

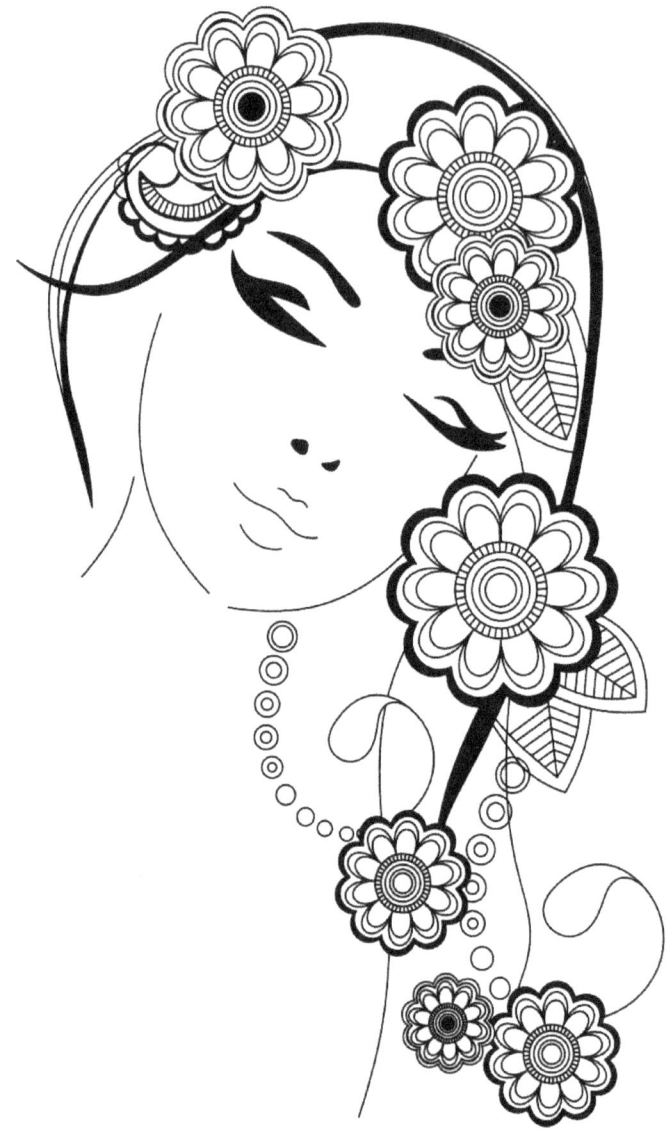

Step Three: Now you must add even more Zen flowers of varying size. As you can see there is indeed some overlap here. Pay close attention to the areas that may need to be erased but also adjust the lines where you can. The importance is definitely on the flowers and leaves, so pay attention to those patterns and keep a close eye for those bold lines again.

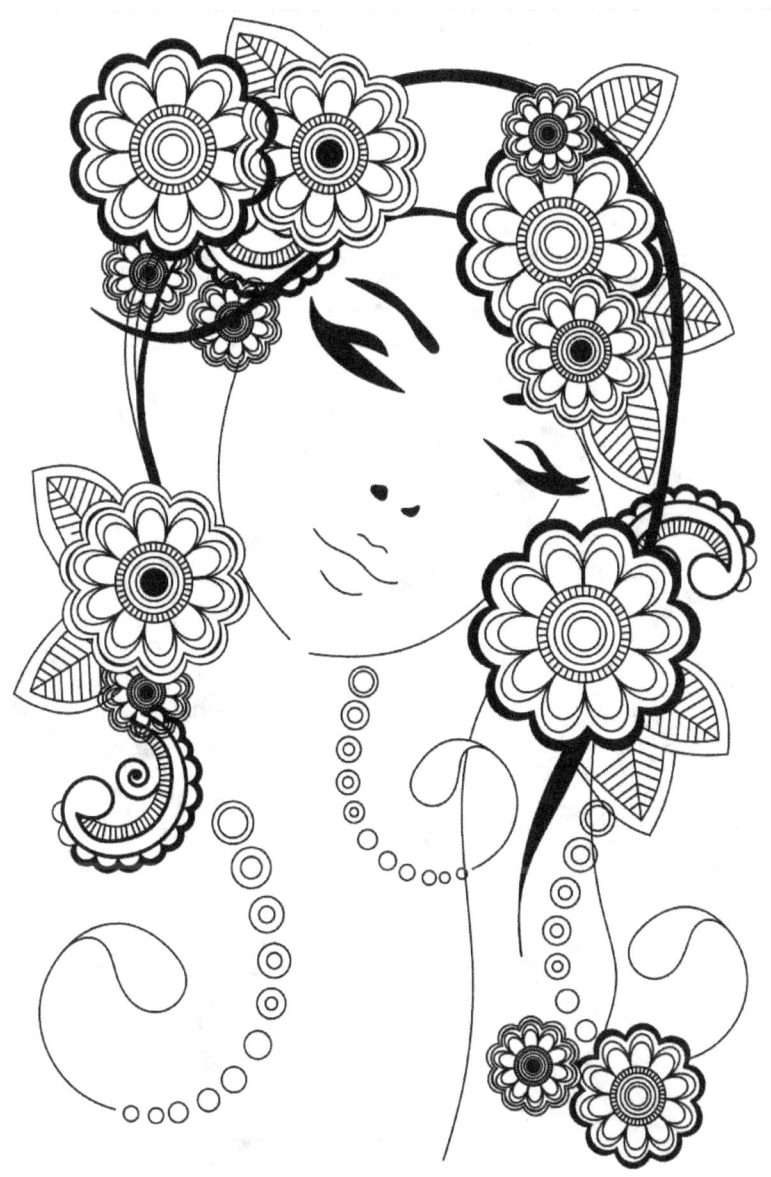

Step Four: Final step. More of the last step, just adding more flowers and leaves. The exception being that this time you're filling in whatever blank spaces you had before. So again, do as before, utilizing the skills you've learned this far and pay attention to your line-work. There is very little

symmetry in this overall image yet a ton of it in each flower, keep that in mind and great work!

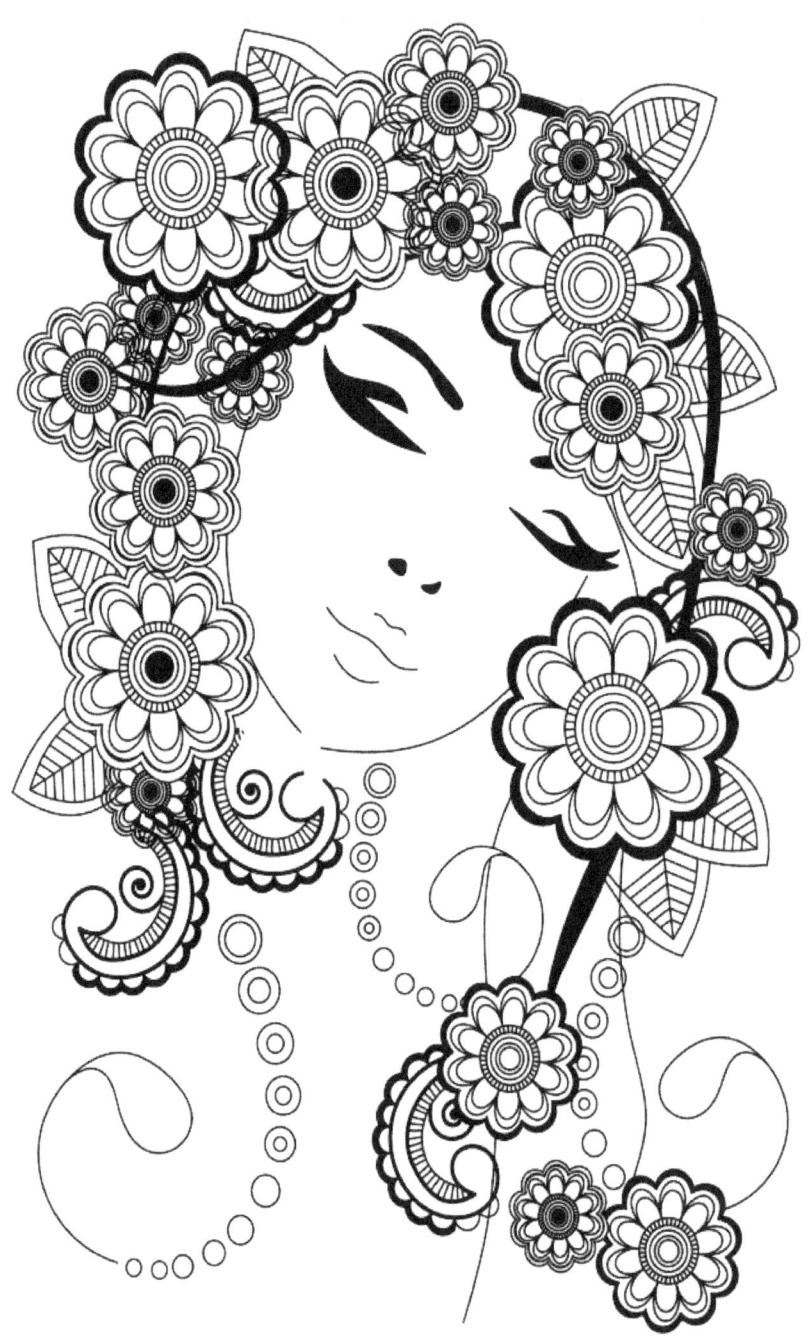

# Zen-Doodle Eyes

This is the final Zen doodle you will need to complete in this book and then you are a doodle master. This is also one of the most beautiful ones out there. It starts off very simple, but gets quite interesting.

Step One: You start out with basic lines for the eyes and eyebrows, as well as a curved line through the eyes so you have a foundation to work off of in relation to the eyes spacing.

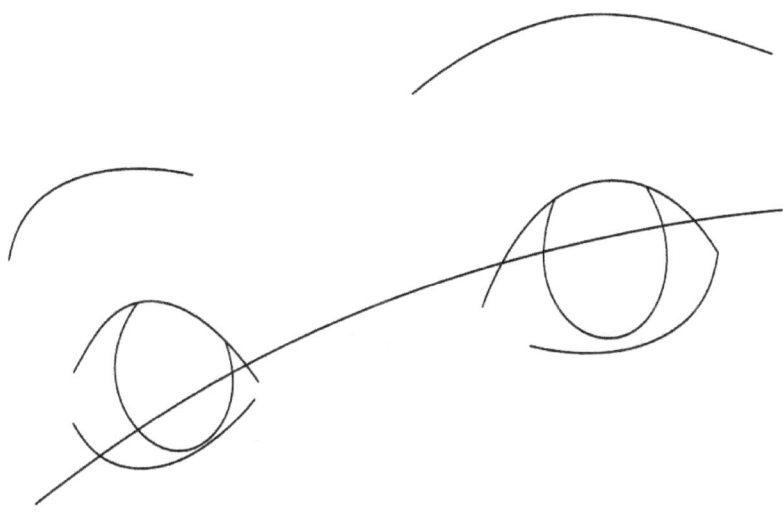

Step Two: Now you start adding in the features of the eyes, including the iris and pupil. Also more structural facial additions and hair. You'll see the lighter grey lines indicate soft lines so pay attention to that.

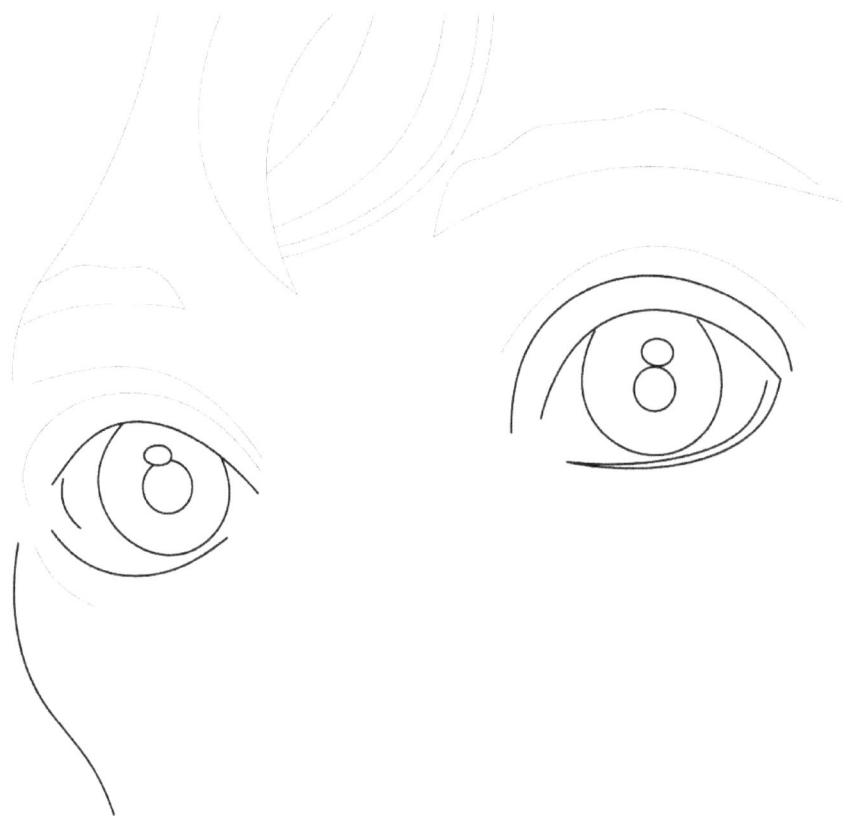

Step Three: Now it's time to add even more detail, start with the eye lashes and then add in even more hair. Again, keep your eye on the soft grey lines and the bolder ones used in the eyes.

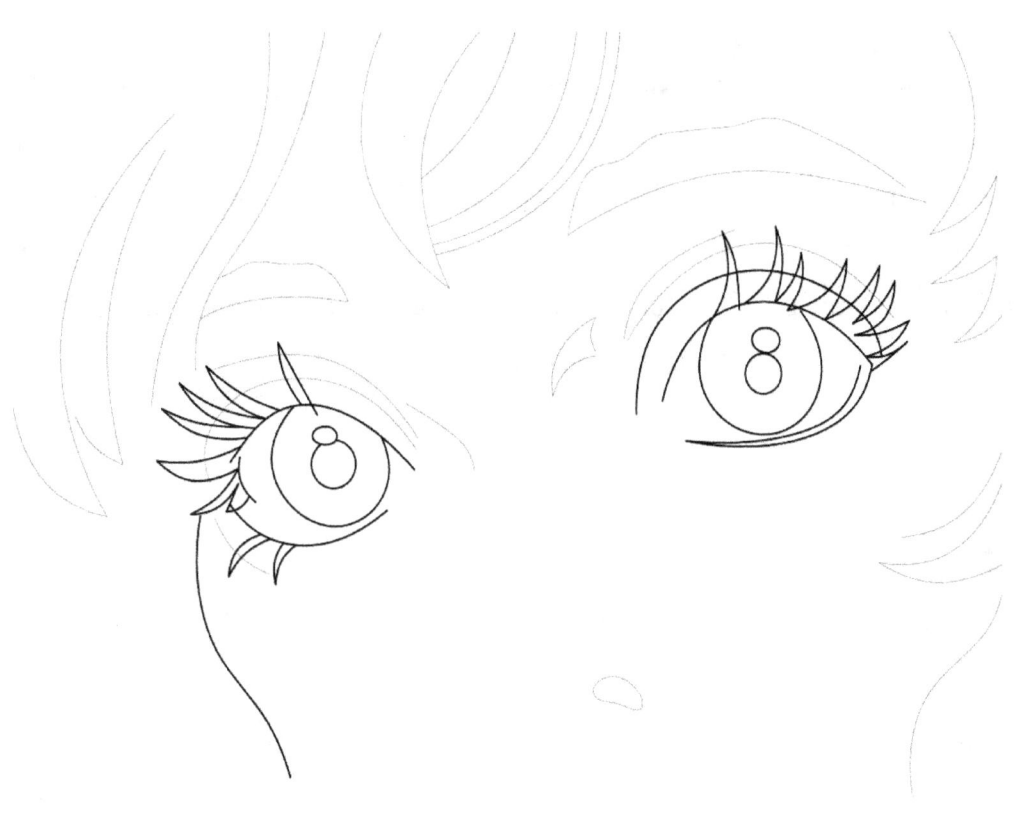

Step Four: The very last step also adds the most detail. Now you will be adding in intricate patterns where the hair used to be as well as really hard bold shading for the eyelashes and eyebrows including the nostril. The eyes in this one really pop and are brought out excellently by the surrounding designs. Use all of what this book has taught you to finish this one, and rejoice in completing the final doodle!

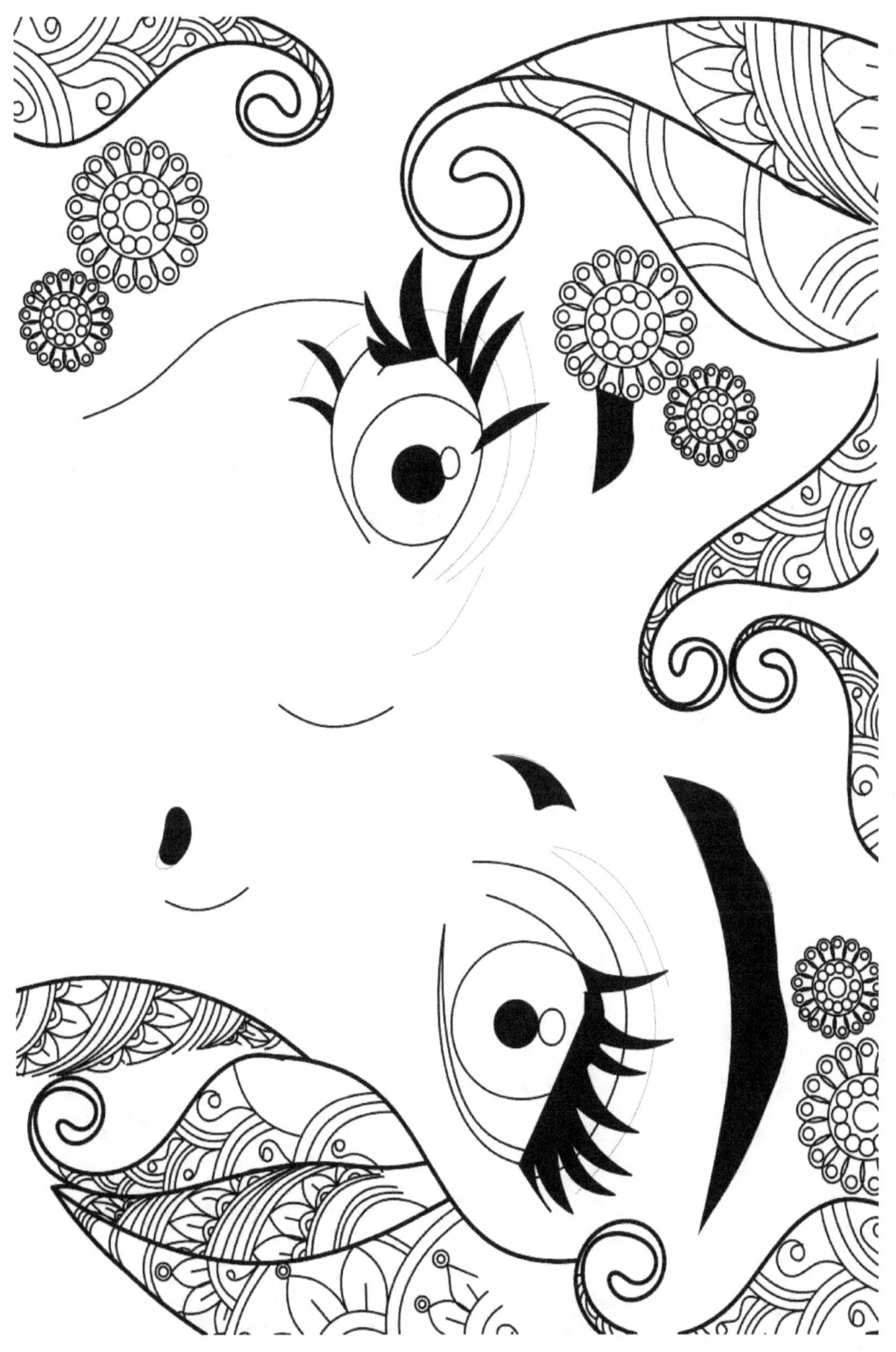

# Conclusion

Now you know all you need to know in order to create your very own Zen-doodle or take on any pre made one that you can find. This book has massive reuse value and there is no end to the possibilities in remixing the doodles this book contains. The main lesson in this book is to take your time with the drawings and find a peaceful and tranquil place within while you move through these exercises. If you managed to find that then you've truly succeeded. If not, then try again and take even more time, and make are you're breathing. Zen-Doodles are a great way to find a state of peace in your surroundings and an excellent way to relax. So enjoy what this book has already shown you, as well as what else is out there. I hope you feel relaxed!

# Templates

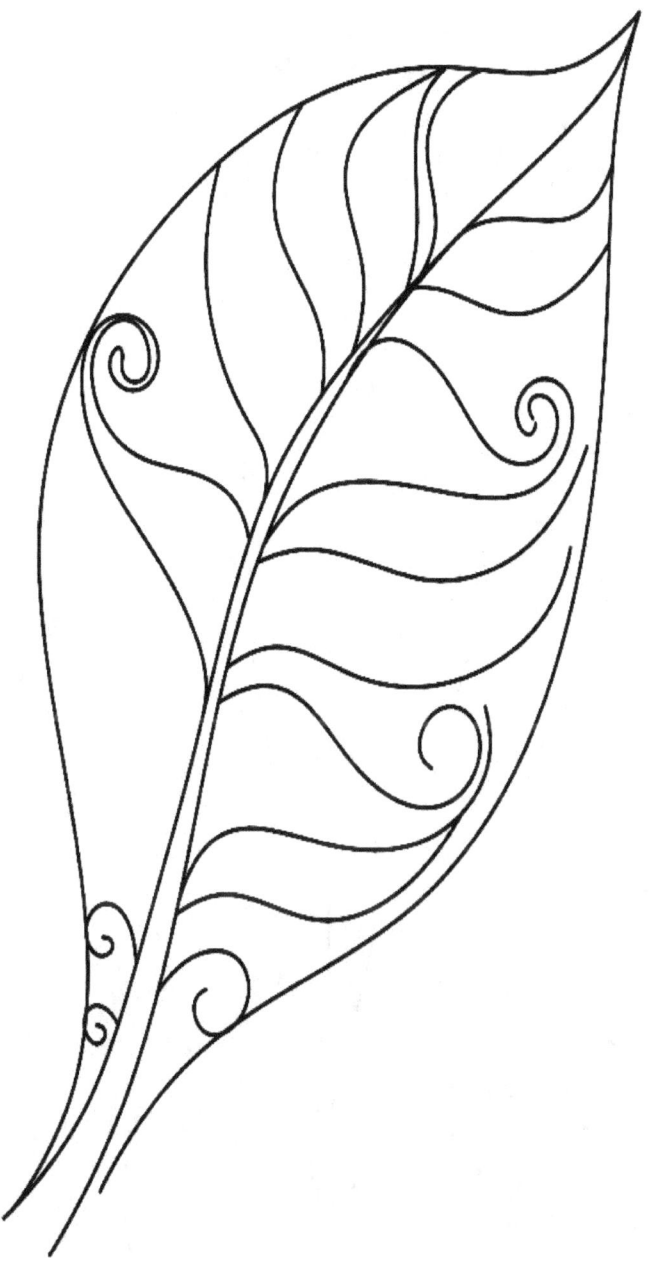

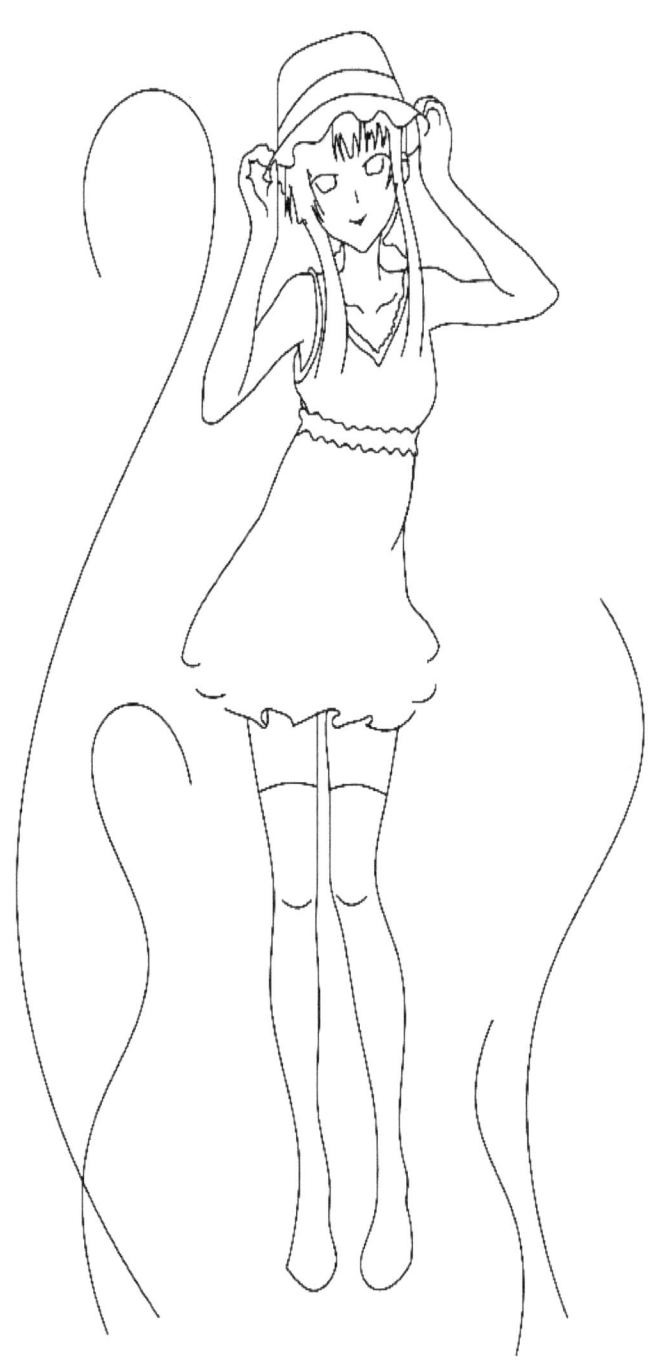

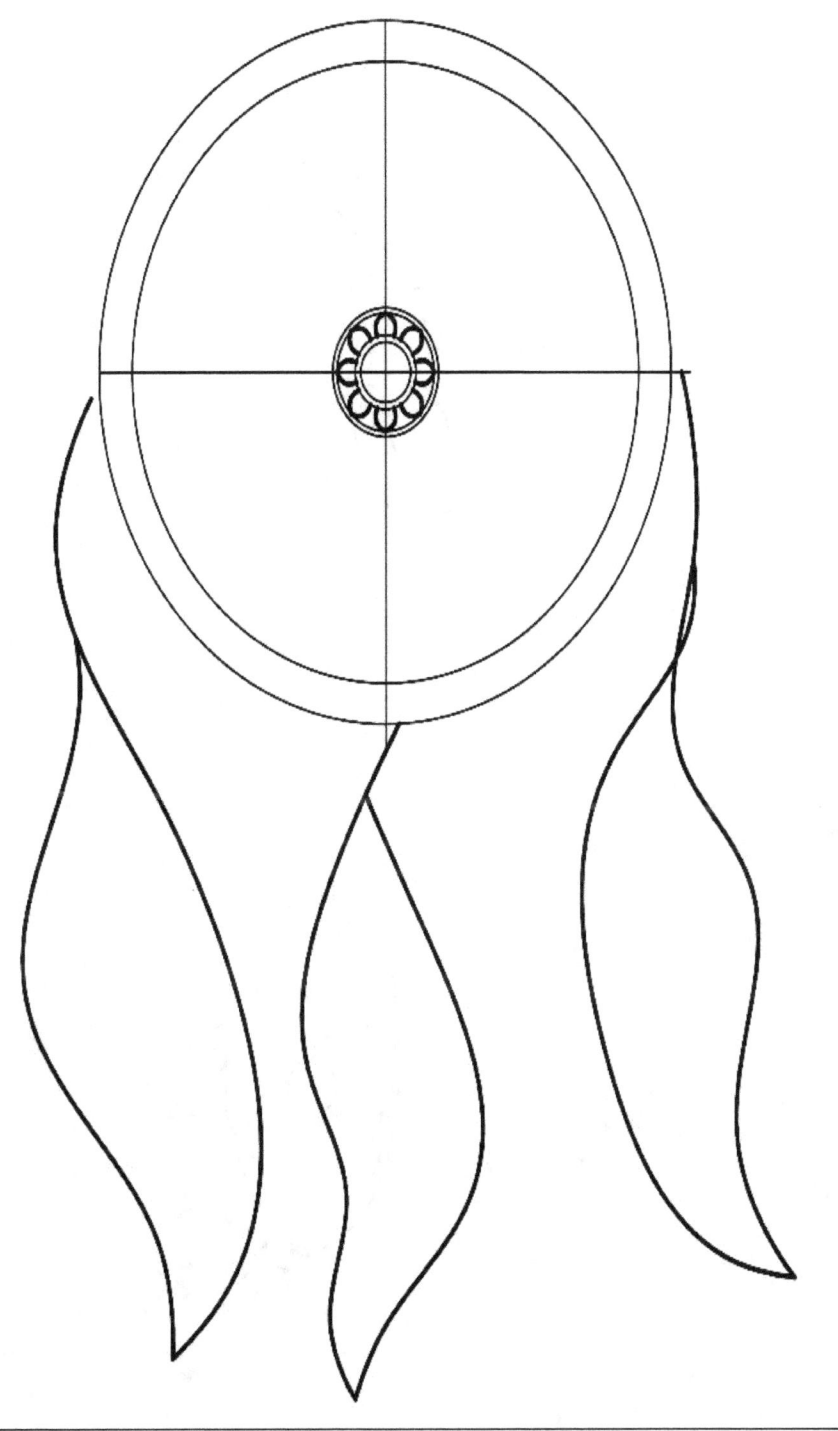

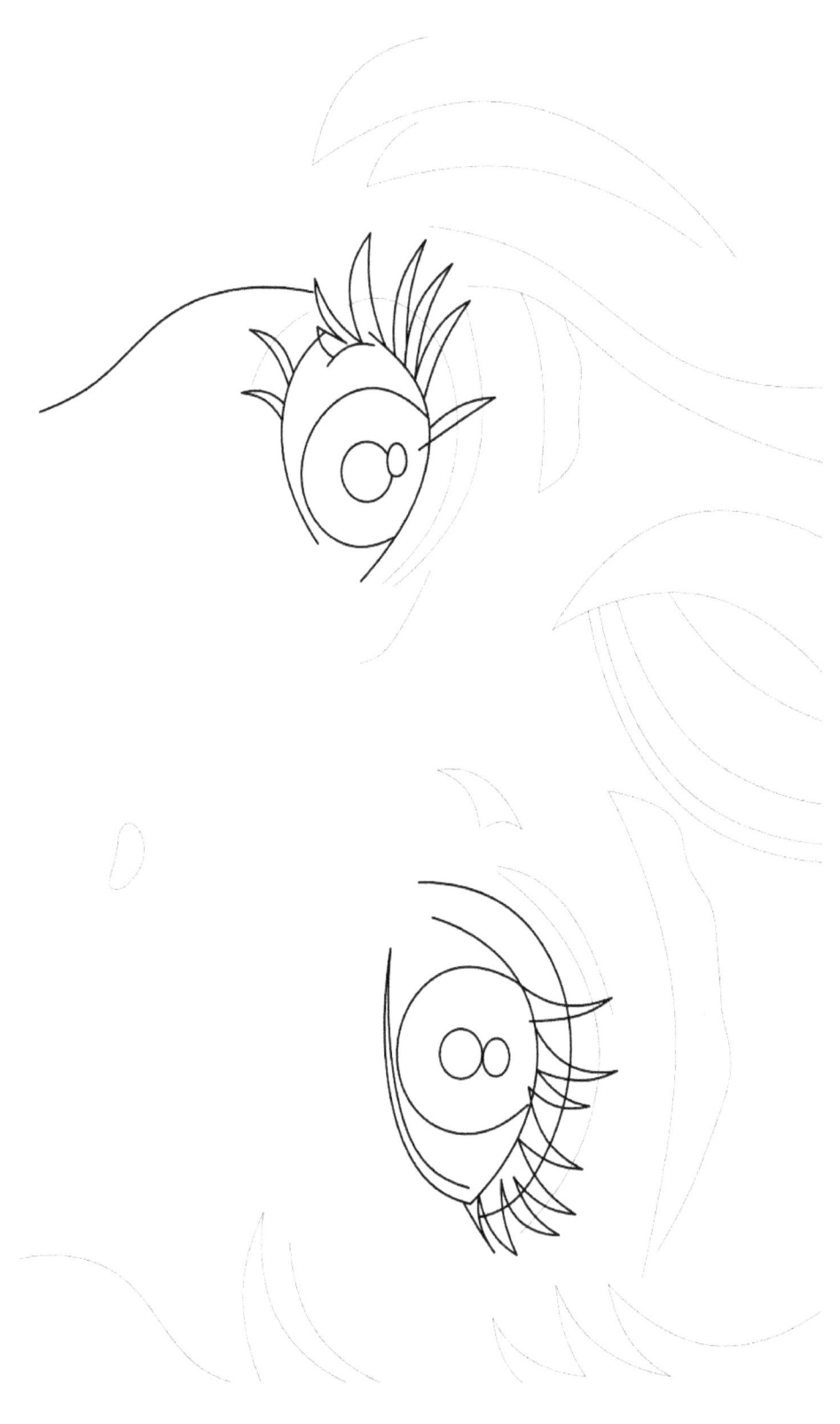

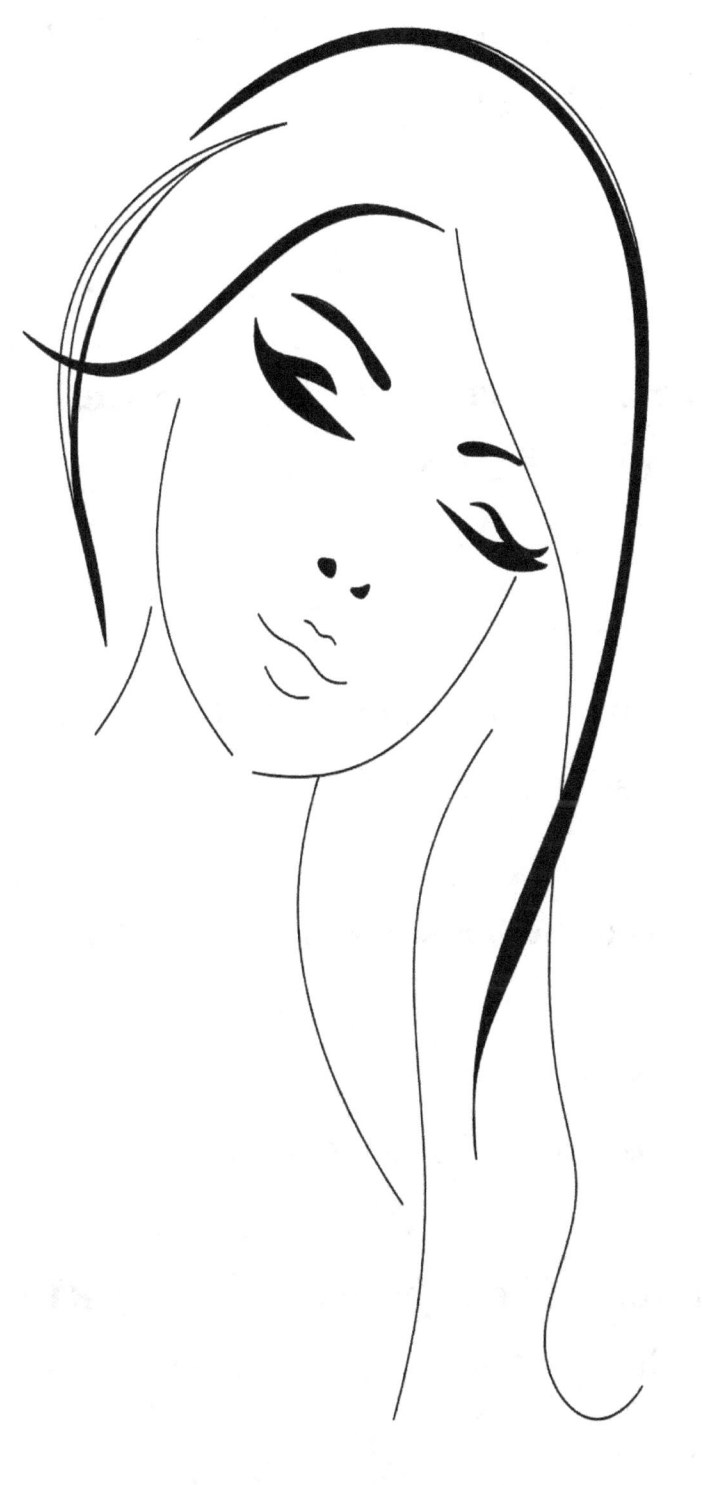

# Thank you!

**To download Templates for practicing please follow the link below:**

https://drive.google.com/open?id=0B4t4JPQNlFacUURvdllOaG91T1k

**If you have some problems with downloading, please, write me:**

gloria.kemer@gmail.com

Thank you for choosing our book, we hope you found it interesting and helpful.

If you liked the book, please give us a favor to write your review.

We would really appreciate this!

If you would like to have a bonus – **FREE BOOK**, please send the screenshot of your review to this e-mail:

**gloria.kemer@gmail.com** and we will send you a **FREE BOOK** in PDF as a **GIFT!**\*\*

Hope to see you in our future books and good luck in your drawing experience!

\*\* **in the e-mail subject please mention the name of the book you reviewed and the author.**

www.ingramcontent.com/pod-product-compliance
Lightning Source LLC
Chambersburg PA
CBHW081253180526
45170CB00007B/2409